IMAGES
of America

PASADENA
A NATURAL HISTORY

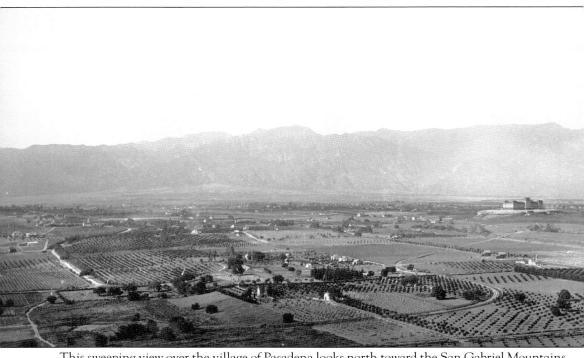

This sweeping view over the village of Pasadena looks north toward the San Gabriel Mountains. Fields and new orchards are spread like a neat quilt over the land. At right, the Raymond Hotel presides over the landscape from its obviously leveled hilltop. Although the photograph is undated, this first Raymond Hotel existed from 1886 to 1895, which gives a rough dating. An 1880s promotional pamphlet for the town declared, "The remarkable clearness of our atmosphere strikes strangers at once." Also the picture shows the dominance of the mountains, which were visible from everywhere in the sparsely settled valley. Compare this photograph (including the mountain ridgeline) with the last one in this book, a 21st-century Pasadena view. (Courtesy The Huntington Library.)

ON THE COVER: An ancient coast live oak provides an idyllic moment in a 19th-century Pasadena childhood. (Courtesy Pasadena Museum of History.)

IMAGES
of America

PASADENA
A NATURAL HISTORY

Elizabeth Pomeroy

ARCADIA
PUBLISHING

Published by Arcadia Publishing
Charleston, South Carolina

Printed in the United States of America

Library of Congress Catalog Card Number: 2007928965

For all general information contact Arcadia Publishing at:
Telephone 843-853-2070
Fax 843-853-0044
E-mail sales@arcadiapublishing.com
For customer service and orders:
Toll-Free 1-888-313-2665

Visit us on the Internet at www.arcadiapublishing.com

For Kaiya and Jacqueline

Contents

ACKNOWLEDGMENTS

I am grateful to the staff members of the libraries who provided expert assistance with these photographs: Jennifer Watts and Erin Chase at The Henry E. Huntington Library in San Marino; Dan McLaughlin at the Pasadena Public Library; Carolyn Kozo Cole at the Los Angeles Public Library; and Susan Snyder at the Bancroft Library. Very special thanks go to Laura Verlaque at the Pasadena Museum of History. Thanks also to Jeannette O'Malley, executive director of that museum. Others who shared abundant knowledge of Pasadena's history and nature were Mickey Long, Chuck Haznadl, Helen Wong, Kate Lain, and the docent-naturalists, all at Eaton Canyon Nature Center; as well as Don Rogers, Ron Cyger, and Ram Vasudev of Pasadena Audubon. Gabi and Cliff McLean of the California Native Plant Society shared expertise and Gabi's beautiful photographs; Sid Gally and Ann Scheid added historical knowledge. Thank you, Dave Douglass, dean of natural sciences and professor of geology at Pasadena City College, for lending the early topographical maps of Pasadena. Jason Pelletier and the staff of North East Trees were helpful, as was Tim Brick, water expert extraordinaire, of the Arroyo Seco Foundation. Sierra Club friends provided ideas and encouragement. Renee Strouse took to the skies for the beautiful aerial photographs. I am especially grateful to my wonderful daughter-in-law Kim Tso for her technical aid with the disks and final stages of the book. Finally, my editor Debbie Seracini was a helpful presence with advice and enthusiasm as we went along. Thanks to you all!

INTRODUCTION

The landscape was serene and the weather fine that midwinter day in January 1874. A group of 27 settlers met on a knoll beside the Arroyo Seco to picnic and subdivide their 4,000 acres of land, launching a new village under the California sunshine. The land, purchased for $25,000, had been platted in 15-acre parcels. Each investor chose lots equal to the number of his shares in the association they had formed. Their subdivision stretched mostly south along Orange Grove Avenue from that first hilltop, which became known as Reservoir Hill. The site is just west of the present intersection of Walnut Street and Orange Grove. Some of the land, stretching north toward the mountains, was to be owned communally.

The following year, seeking a Native American name with a pleasant sound, the newcomers named their colony "Pasadena," from a Chippewa word suggesting "Crown of the Valley."

It was the area's natural attractions that had drawn them there. In 1873, a group called the California Colony of Indiana was determined to leave behind the hardships of their Indianapolis winters. They sent their agent, Daniel Berry, in search of Southern California land, well-watered and suitable for raising citrus. Berry visited the Rancho San Pasqual, which had once been part of the vast San Gabriel Mission holdings.

He negotiated with Benjamin D. (Don Benito) Wilson and John S. Griffin, co-owners of a broad rancho already set with orange groves and vineyards. Staying overnight at the nearby Fair Oaks Ranch with Judge Benjamin Eaton, brother-in-law of Griffin, Berry was charmed by the clear air and the springs in the rocky canyons. He awoke "to the music of a thousand linnets and blackbirds in the evergreen oaks. It was the sweetest sleep of years," he wrote home.

The colonists, who had incorporated as the San Gabriel Orange Grove Association, chose their homesites without dissension. This was an auspicious beginning for the new settlement of fruit growers, though they acknowledged "there was not a horticulturist among them." Optimism was inevitable, and nature would provide.

An observer described their new landscape as follows:

> To the south, rolling hills and quiet valleys, far reaching plains beyond the town of Los Angeles, the Pacific Ocean shining in the distance. To the west, hills more abrupt and wild, with the Arroyo Seco winding picturesquely northward. To the east and northeast, snow-capped Old Baldy, and a fertile rolling plain fading away in the distance.

A second subdivision of land was made by B. D. Wilson in 1876 because sale of the original lots had gone so quickly. The new tract, separated from the first by Fair Oaks Avenue, added 2,500 acres eastward under the name of the Lake Vineyard Land and Water Company. Pasadena was filling out a substantial acreage, developing its waterways, and routing its streets to save its beautiful native oaks (which were sometimes left in the center of the quiet roadways). About 40 families had settled in by 1877.

The early colonists' experience with nature is typified in a firsthand account by Dr. and Mrs. O. H. Conger. Their first Pasadena home was one long room of matched redwood boards, with a door in each end. They began by raising potatoes, white beans, lettuce, and onions. The second

year, they set out 300 small orange trees, and a few months later, grasshoppers descended. They covered each and every tree with muslin and saved them all. Later their 30 acres were set to grapes, oranges, and deciduous fruits. The Congers cured their first raisins by hanging bunches of grapes on nails driven into the south-facing side of their house. Their property was on the southeast corner of today's Colorado Boulevard and Orange Grove Avenue.

Other memoirs tell of abundant jackrabbits and coyotes, bears and mountain lions near the canyons, rattlesnakes and tarantulas visible but generally moving on as human settlement expanded. Abundant bird life and the red-tailed hawks overhead were part of nature's endowment. The expanse of open land, some of which had been sheep pasture, was covered with low grasses and scattered native oaks. Thickets of vegetation grew along the canyon streams.

New chapters came rapidly in the life of Pasadena. In 1885, the first passenger train arrived, and in 1886, the city voted to incorporate, with 232 votes cast in total. Agriculture prospered, especially in citrus, vineyards, and fields of barley and hay. Beekeepers made a solitary living in the foothill niches.

Then a rate war between the Santa Fe and Southern Pacific Railroads brought on a land rush remembered as the "Boom of the Eighties." Hundreds, then thousands, of immigrants came to Southern California to settle or to winter in the irresistible climate. Eastern visitors thronged to the Raymond Hotel, the Maryland, the Green, and many smaller hostelries. Quickly the once rural community became more affluent, still valuing its countryside but now increasingly sophisticated.

A parallel chapter was the arrival of the "health seekers," sometimes called the California health rush. Between 1870 and 1900, doctors in the East and Midwest were ordering a change of climate as the first remedy for consumption, asthma, and other ills. Invalids flocked to Pasadena to try the tonic of mild weather and the open air. For a time, sanitariums and even tents for the ailing were sprinkled across the sunny foothills.

In the 20th century, urban growth continued and the city's relationship with nature became more wary. Parts of the Arroyo Seco were developed for organized recreation (the Rose Bowl, Brookside Golf Course), while the natural area of Eaton Canyon retained its wild heart. The San Gabriel Mountains saw the so-called Great Hiking Era, when hundreds of hikers enjoyed the trails and rustic resorts flourishing there for several decades. However, after times of fire and flood—the most dramatic being the deluge of March 1938—the city took protective measures, including capturing the Arroyo Seco stream in a concrete channel.

Gradually a system of 23 city parks was developed, and a broad canopy of street trees now gives Pasadena a far more green and shady aspect than when the settlers of 1874 arrived. Today the city is nearly built out and has about 146,000 residents. With annexations over the years, its area has grown to about 22 square miles.

Pasadena, sometimes called "a city with a conscience," is embracing green values in the 21st century, creating open-space plans like the Sensitive Lands Inventory and the Park Masterplans. Naturalists lead schoolchildren in Eaton Canyon while a "stream team" monitors water quality in the Arroyo Seco, and native plant gardens are becoming popular.

Living in harmony with nature is now a widespread ideal in the city. Pasadena's natural history is not just a memory of the past but a living companion for the present.

One

THE TERRAIN AND THE CLIMATE

Pasadena is situated on a broad alluvial slope below the San Gabriel Mountains, earlier called the Sierra Madre—a transverse range (trending east-west). These are young mountains, with deep canyons, but composed of very old rocks. This rocky base, shattered by weathering and earthquakes, is washed to the lowlands as alluvium, the porous layers of gravel favorable for native plants and citrus.

The range above Pasadena is drained by two large canyons, the Arroyo Seco to the west and Eaton Canyon to the east. The stream and springs at Devil's Gate, a narrow rocky defile in the arroyo just south of today's Hahamongna Watershed Park, provided most of the water for Pasadena's earliest settlers.

Other waterways were found along the southern edge of the present city, where water-bearing bluffs extended from Raymond Hill eastward to San Marino. A series of seven parallel canyons, all within the space of two miles, descended sharply, carrying their streams. Today most of these canyons are occupied by streets, such as Los Robles Avenue and El Molino Avenue.

The gently rolling land had few distinct hills, except for Raymond Hill (on the border with South Pasadena), Reservoir Hill (now graded and crisscrossed by Colorado Boulevard, the 210 Freeway, and the 134 Freeway), and Monks Hill (a high point in north Pasadena).

The city has a Mediterranean climate, characterized by short wet winters and long dry summers. This climate type, found on less than three percent of the earth's land surface, exists on the west edge of continents between 30 and 45 degrees north and south latitude: Pasadena lies at 34 degrees north. Average elevation for the city is about 960 feet, and the annual rainfall averages about 17 inches. Abundant sunshine and little water determine the animal and plant life (including crops) that thrive here.

As an Eastern visitor wrote: "The most remarkable feature of the climate is its uniformity. January is nearly as warm as July. . . . from December till June is spring, and from June till December is like autumn (excepting hot spells)."

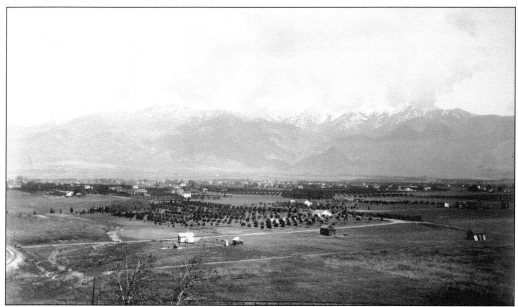

This photograph shows the town center of Pasadena and the mountains, looking north from the Raymond Hotel, a famed hostelry for Eastern winter visitors on a hill south of town. Orchards are underway, but there is still much undeveloped land before the real estate boom of the 1880s. Views like this evoke the "big sky" feeling Pasadena once had with its wide open spaces. (Courtesy The Huntington Library.)

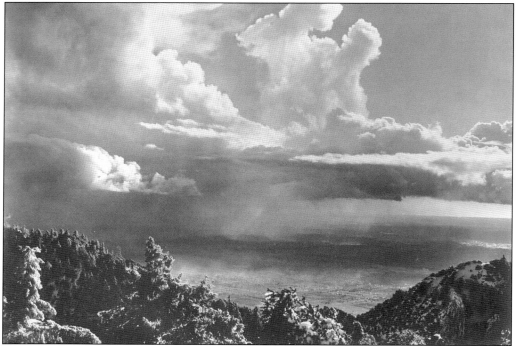

Looking south this time is a view of Pasadena from the mountains. The lofty cloud emphasizes the tininess of the village below in the broad valley. (Courtesy Pasadena Museum of History.)

Pasadena is built on the layers of rock and gravel (known as alluvium) that have washed down from the San Gabriel Mountains over thousands of years. Erosion and earthquake fractures break apart the rocky foundations of the mountains, and the steep gradient of their streams and rivers carries down an abundance of gravel. The gravel quarries along the San Gabriel River are a witness to this. These photographs show stream cuts in Eaton Canyon, near the Nature Center, revealing the rocky substratum of the valley. The gravelly depths are porous and in many areas proved excellent for the settlers' vineyards and citrus groves. (Photographs by the author.)

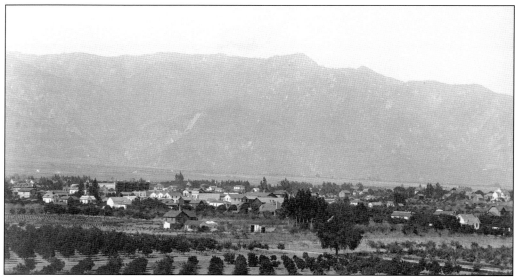

Although the mountain range seemed at first like a simple backdrop (and a constant presence), the colonists later ventured into its interior and discovered there are depths of ridges behind this obvious one. (Courtesy Pasadena Museum of History.)

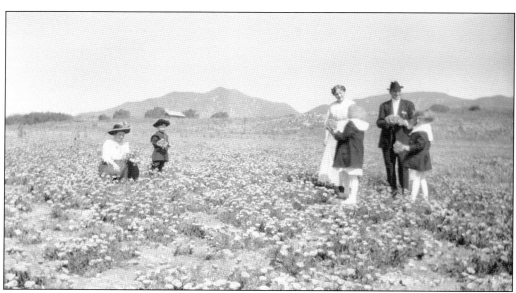

The slopes above the town, where the Pacific Ocean was visible in the distance, were an attraction right away. This floral carpet of golden poppies, shown in 1913, was much photographed to show Easterners the appealing climate of Pasadena. (Courtesy Pasadena Museum of History.)

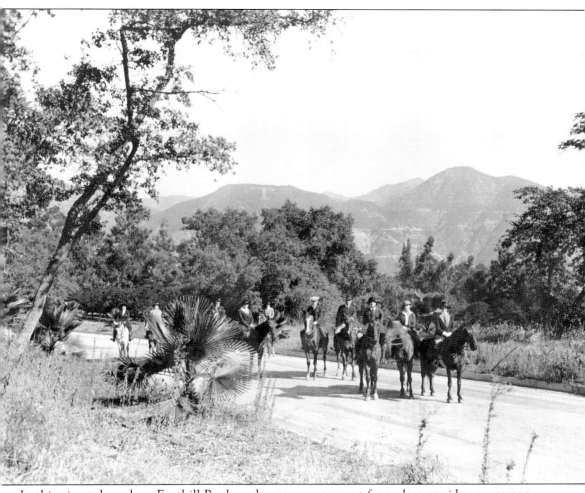

In this view taken along Foothill Boulevard, a group seems out for a pleasure ride on a serene country road within early Pasadena. Although the photograph is undated, a clue emerges in the large letter "T" visible on the mountain slope. In 1891, just five years after Pasadena was incorporated, Amos G. Throop founded Throop University, later known as Throop Polytechnic Institute. In 1921, the school became the California Institute of Technology (Caltech). (Courtesy Los Angeles Public Library.)

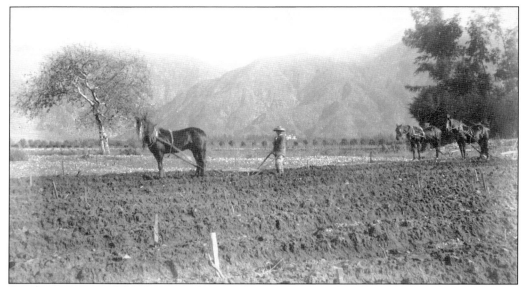

Grapes were successful early in Pasadena's agricultural years. Judge Benjamin Eaton set an example of growing them with little or no irrigation. Later he helped the colony develop exemplary water systems. Here a Chinese worker plows a vineyard on what appears to be a sunny midwinter day, with snowy mountains beyond. (Courtesy The Huntington Library.)

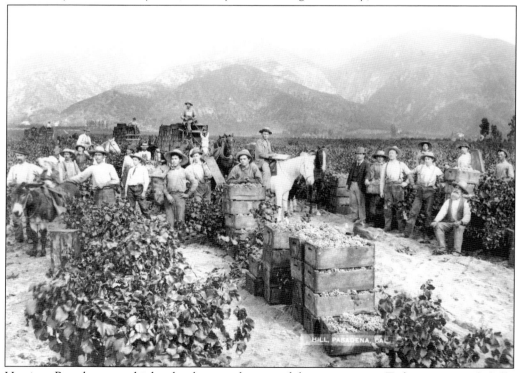

Hastings Ranch was on higher land out to the east of the town center. Today it is a gently hilly residential neighborhood. This undated photograph shows workers picking grapes there. (Courtesy Pasadena Museum of History.)

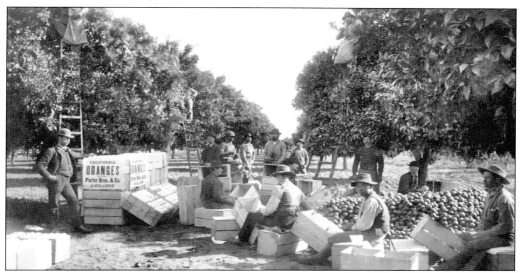

This scene of picking oranges was repeated many times over as Pasadena's groves developed. An early promotional writer stated that fruit and vegetables were maturing in every month of the year, a claim itemized with 22 different species, from citrus, figs, apples, and grapes, to stone fruits, berries, and pomegranates: "a perpetual harvest-time." (Courtesy Pasadena Museum of History.)

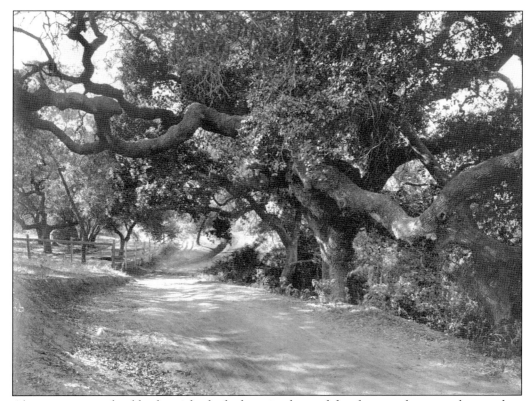

Along country roads, old oaks might shade the quiet thoroughfare from one homestead to another, as in this undated view on the Allendale Ranch. (Courtesy Pasadena Museum of History.)

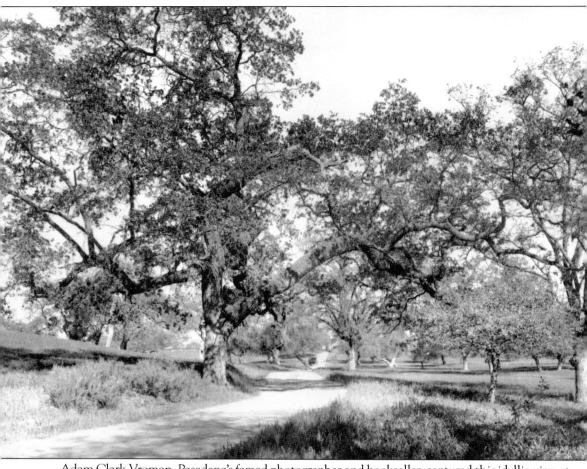

Adam Clark Vroman, Pasadena's famed photographer and bookseller, captured this idyllic view at the ranch of E. J. ("Lucky") Baldwin, showing a road eastward to present-day Arcadia. A visitor to the Los Angeles County Arboretum in that city can still see oaks like this and briefly get a sense of the open woodland once part of Pasadena's varied terrain. (Courtesy Pasadena Public Library.)

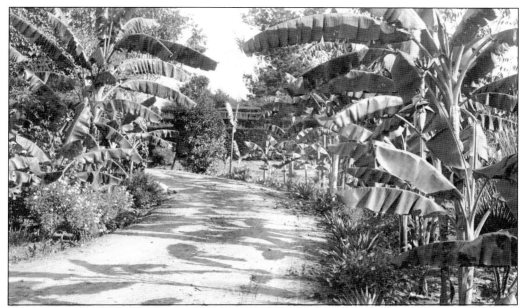

Settlers from the Midwest and the East were amazed at the climate, where practically anything would grow—and larger, too, than the flora known at home. Here bananas flourish along a roadway, giving a tropical touch that Southern Californians still enjoy. (Courtesy Pasadena Museum of History.)

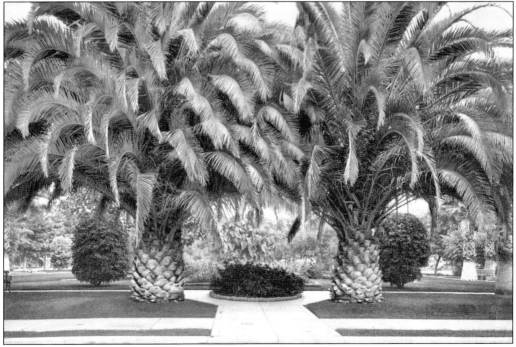

These date palms have been arranged in a formal garden style, clearly part of the transition between a rough rural scene and the more carefully arranged Victorian gardens of Pasadena after the 1880s. (Courtesy Pasadena Museum of History.)

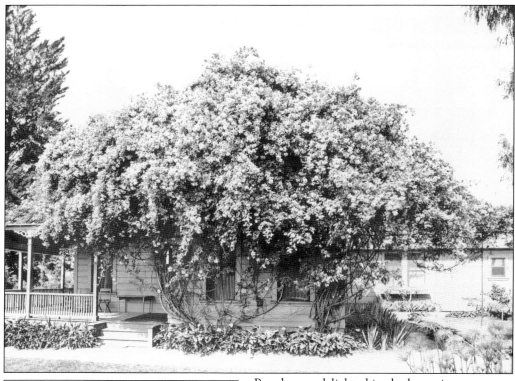

Pasadenans delighted in the huge size that plants could attain. Here a cottage is submerged under the Gold of Ophir roses, which were a great favorite. Perhaps these prodigy roses came from cuttings brought from previous homes, and they reached abundance never possible in the colder climes. (Courtesy Pasadena Museum of History.)

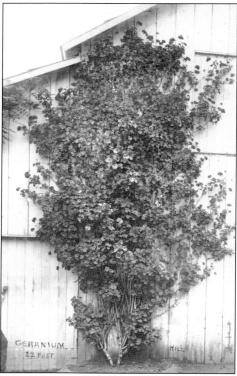

This is alleged to be a 22-foot geranium, yet another example of the grand scale of Pasadena's flora. A photograph like this could attest to the Pasadena climate better than words. (Courtesy Pasadena Museum of History.)

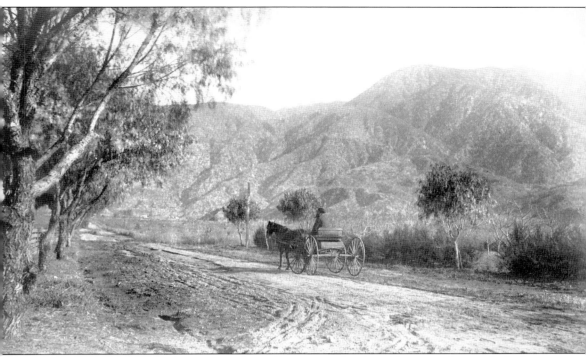

East of town, beyond acres of groves, another village center developed known as Lamanda Park. Today the area has long been annexed into Pasadena, but the name survives in the Lamanda Park Branch of the city's public library, on Altadena Drive. This undated photograph suggests the serenity of a slow journey by buggy in that area, toward the neighboring village of Sierra Madre. (Courtesy The Huntington Library.)

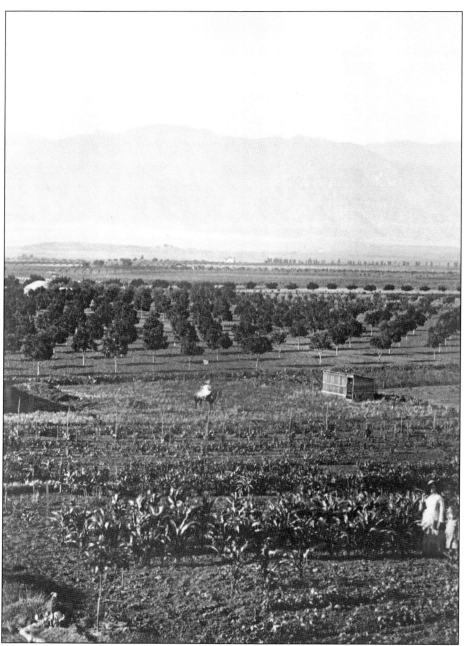

This view and the one on the facing page form a panorama, looking east, of Dr. Ezra and Jeanne Carr's 42-acre property, which they acquired in the 1870s. The Carrs were friends of John Muir, who first came to Pasadena in 1877 and later visited them a number of times at this place. Jeanne Carr described her land as "a vast storehouse of weeds kept in partial subjection by pasturage," for it had supported large bands of sheep in the ranching years. This raw and sun-scorched land stretched east from the settlers' Reservoir Hill: from Orange Grove Avenue along the north side of Colorado Boulevard. Today the Norton Simon Museum occupies that hilltop. (Courtesy The Huntington Library.)

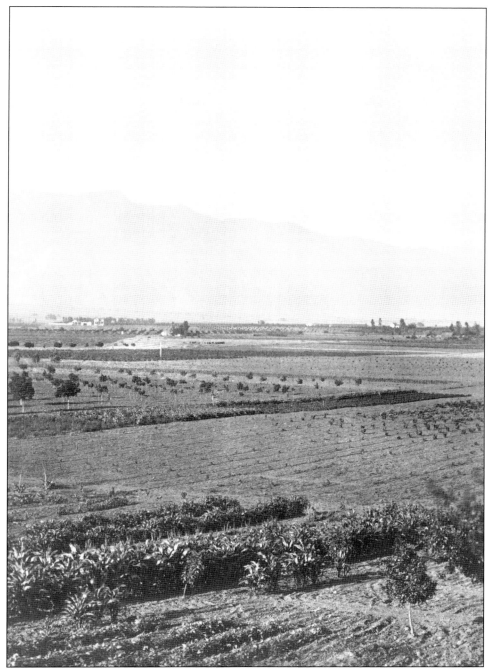

The Carrs created on this bare land their marvelous garden called Carmelita. Within the space of a dozen years, about 90 varieties of trees were planted, species from around the world. Jeanne Carr set out a border of Mexican limes, a favorite edging for citrus orchards then, and also planted hedges of Monterey cypress, Cherokee roses, and climbing grapes. A few of the tallest trees still in the Norton Simon Museum garden may date back to those pioneer times. (Courtesy The Huntington Library.)

Land development interests looked eagerly at the most beautiful spots. This 1902 photograph, from a promotional piece, is described as: "Beautiful 'Oak Knoll,' probable site of Pasadena's next great tourist hotel." As predicted, the Wentworth Hotel was opened on the knoll in 1905. After financial difficulties, the hotel was completed and renamed for its new owner, Henry Huntington, in 1914. It was a winter retreat until 1926, at which time it was open year-round. (Courtesy Pasadena Museum of History.)

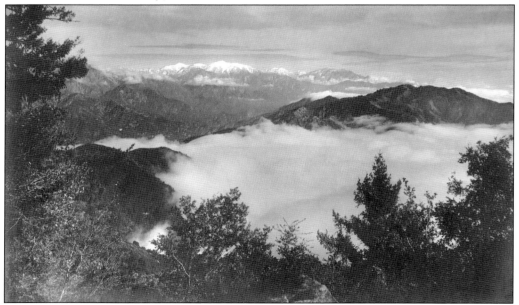

Pasadena's infrequent cloudy days sometimes made picturesque effects as cloud layers alternated with mountain ridges. Nevertheless, rain was eagerly awaited in the agricultural years. One observer, writing in an 1886 pamphlet, declared: "Since the country has been cultivated the rainfall has perceptibly increased, and there is a fair prospect that the dry years will almost entirely disappear." (Courtesy Pasadena Museum of History.)

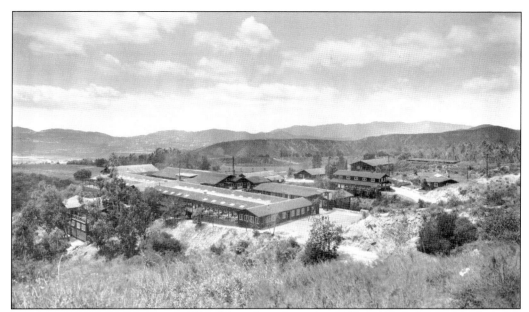

Pasadena saw a huge migration of health seekers from the 1870s to 1900. Private sanitariums sprouted up outside the town, some just shacks or tents. La Vina Hospital (shown here in 1930) was founded in 1909 and closed in 1984. The buildings seen here burned in 1935 and were replaced by an innovative Myron Hunt design in 1936. Today houses cover the site above Altadena. (Courtesy Pasadena Museum of History.)

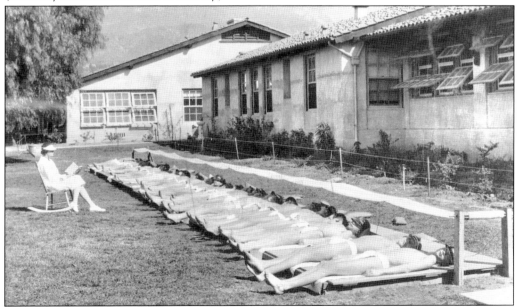

Here, in 1928, a nurse watches over 20 boys sunbathing at a children's health school somewhere in Pasadena. The area's sunny climate and tonic fresh air were extolled in newspapers from east to west. Doctors nationwide ordered change of climate as the remedy for consumption, asthma, and other ills. It was believed that different elevations in the hills were best for different diseases. (Courtesy Los Angeles Public Library.)

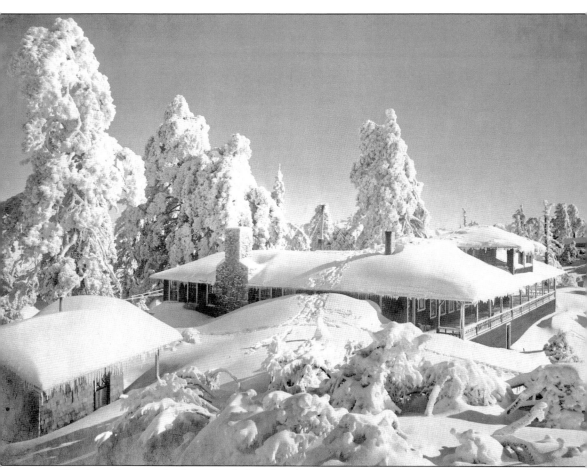

Comfortably warm in the valley below, Pasadenans also enjoyed the climate contrasts of having snow near at hand. One visitor wrote this rather extravagant thought: "In the winter time the tourist may eat strawberries at the Painter Hotel for breakfast, and in the afternoon enjoy the excitement of the toboggan over the slopes of the Sierra Madres [the San Gabriel Mountains] with an orange blossom in his buttonhole." In any case, he might visit the now-gone Mount Wilson Hotel, here blanketed in snow in about 1911. (Courtesy Pasadena Museum of History.)

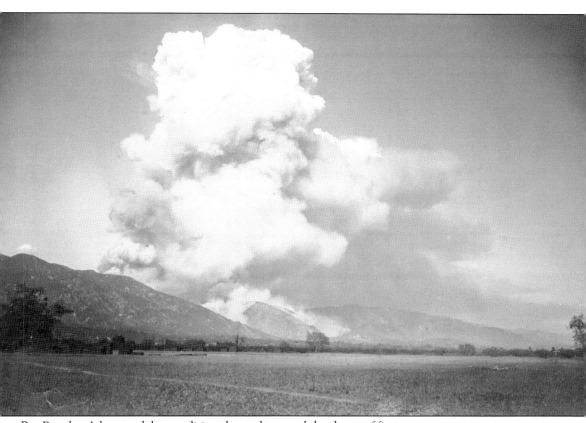

But Pasadena's heat and dry conditions have also posed the threat of fire, a common occurrence—and a natural one—in the San Gabriel Mountains. This undated early photograph shows a spectacular plume in the years before modern firefighting, when human occupation of the mountains was low and the fires could provide their benefits to nature's habitats. (Courtesy Pasadena Museum of History.)

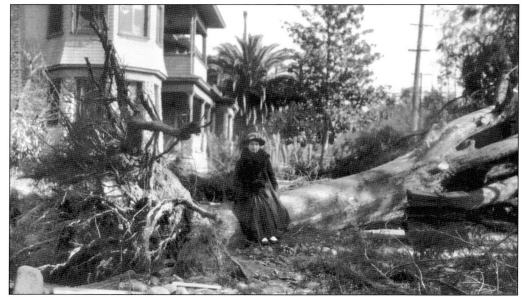

Pasadenans today are familiar with the fierce winds that sometimes sweep through the city in midwinter, scouring off roof tiles and knocking over well-loved trees. This photograph of January 1918 shows the same phenomenon long ago and the loss of a major tree. (Courtesy Pasadena Museum of History.)

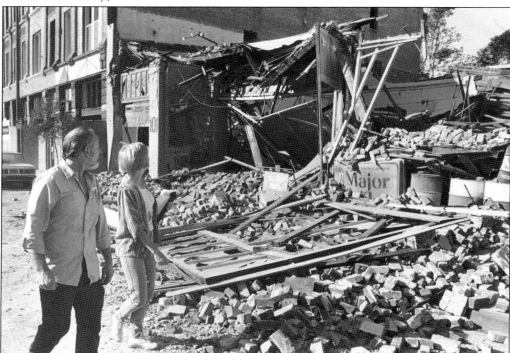

Not part of the climate but definitely a force of nature are the region's earthquakes. This building on Fair Oaks Avenue in Pasadena collapsed in the quake of October 1987, flattening several cars but causing no injuries to people. (Courtesy Los Angeles Public Library.)

Two

THE ARROYO SECO

The Arroyo Seco was the original home and heart of Pasadena. Its stream, an important tributary of the Los Angeles River, begins high in the San Gabriel Mountains and drops steeply through the Angeles National Forest. Reaching the lowlands, its wash opens out into a variably wide, often steep-sided valley, a distinctive feature along the western side of Pasadena. Entering South Pasadena, the stream veers west to its confluence with the Los Angeles River.

Pasadena's original native people, the Tongva (later called Gabrielinos from their connection with the San Gabriel Mission), lived near this waterway. The Indiana Colony uncovered an extensive native town site on Reservoir Hill, just above present-day Brookside Park. The native people found ample food and shelter in the well-watered arroyo (although its name, indicating a variable stream, means "Dry Gulch.")

The new townspeople of Pasadena used the arroyo for irrigation but also for sheep grazing, for orchard planting, as a woodlot, and as haven for some quick, simple dwellings. The alder-shaded stream and willow glades were a refuge from working life. Scores of vintage photographs still illustrate the popularity of 19th-century picnics at the brook and its nearby canyons.

By 1887, the young city already thought of preserving the Arroyo Seco for the public. Theodore Roosevelt, visiting Pasadena in 1903, famously proclaimed that it was a splendid natural park and should be kept just as it was. In 1911, the city began the process of acquiring Arroyo Seco land. Planning for its public use has continued through the generations to the present day.

Today the 8.25-mile stretch of the Arroyo Seco through Pasadena is in three sections: the Upper Arroyo (including Hahamongna Watershed Park), 4 miles from the Angeles Forest to Devil's Gate Dam; the Central Arroyo, 2.5 miles from the Foothill Freeway to the Colorado Street Bridge; and the Lower Arroyo, 1.75 miles from the Colorado Street Bridge to the South Pasadena border. The Upper is a broad, semi-wild expanse, the Central is devoted to recreation sites, and the Lower is pledged as a permanent natural area.

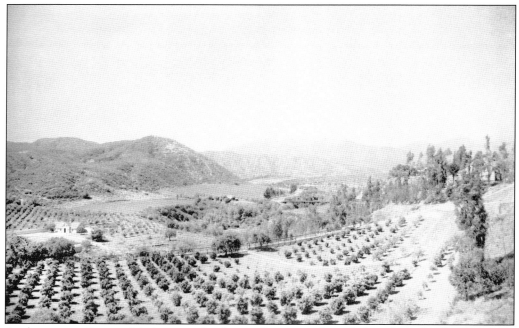

As the source of most of their water, the Arroyo Seco was a logical place for orchards of the early colony. Often steep sided, the arroyo broadened here to a fertile valley bordered by gentle slopes. This photograph, looking north, is undated but compares to others from the late 1880s, as the trees are small. (Courtesy Pasadena Museum of History.)

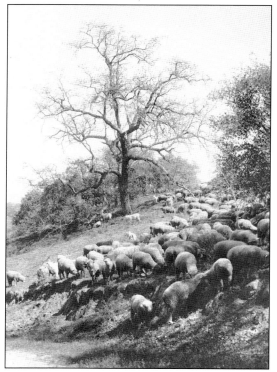

Pasadena's historian, Hiram Reid, writing in 1895, tells of Sheep Corral Springs, a 30- or 40-acre water-bearing slope, part of the Arroyo Seco just below Reservoir Hill (the latter was a high point north of Orange Grove Boulevard and Walnut Street). This view of sheep in the arroyo may have been near those springs. The colonists hauled away sheep manure to fertilize their young orange trees. (Courtesy Pasadena Museum of History.)

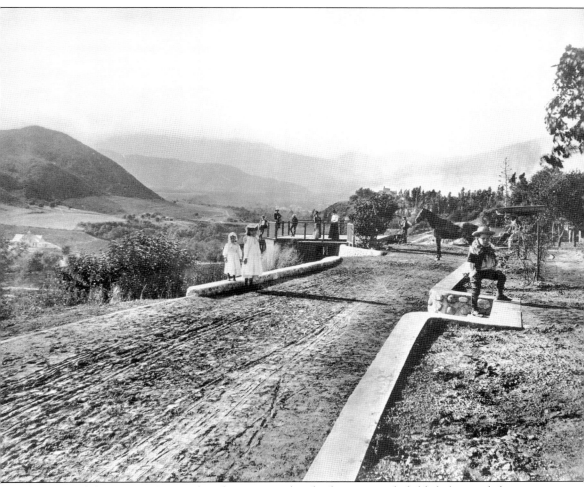

This view of the Arroyo Seco, taken from a steep brink, shows smooth fields below with layers of hills beyond. On the west side of the arroyo, the separate little settlement of Linda Vista was growing. It had first been known as Indian Flat, for there were traces of Tongva life there as at many arroyo sites. Before the arroyo was bridged at several points, its west bank was more oriented to Garvanza and Los Angeles than it was to fledgling Pasadena. The two shores of the arroyo were united in 1914 when residents of the Linda Vista, Annandale, and San Rafael areas voted to accept annexation into Pasadena. (Courtesy The Huntington Library.)

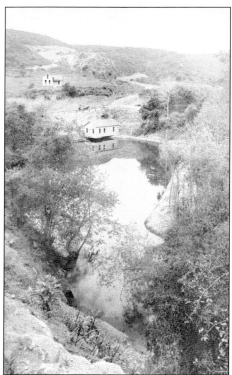

Abundant waters around the Arroyo Seco took various forms, as there were many springs and watering holes created for grazing animals. This pond was in the San Rafael area, in the southwest corner of Pasadena. (Courtesy Pasadena Museum of History.)

In 1900, this horse and buggy made a relatively easy arroyo crossing at a point called the North Ford. The long-skirted ladies appear to be crossing on two planks at the left, not too arduous with the moderate flow. However, early sources indicate that, before the bridges, the arroyo was not passable for months at a time in the rainy season. (Courtesy Pasadena Museum of History.)

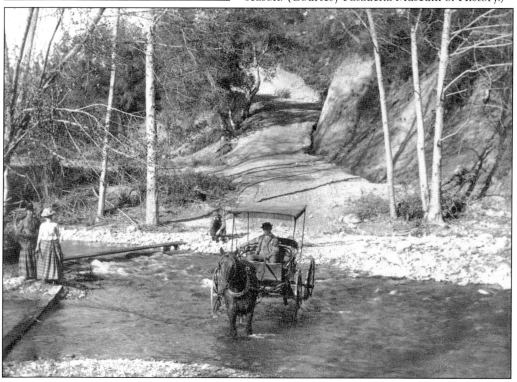

Before construction of the Devil's Gate Dam in 1920, there was good fishing in the arroyo. Early accounts tell of rainbow trout in pools under the Colorado Street Bridge and south of the La Loma Bridge. One fisherman reported he could catch 25 eight-inch rainbows in a couple of hours in these pools. The men in this photograph seem to have scanty waters for fishing. (Courtesy Pasadena Museum of History.)

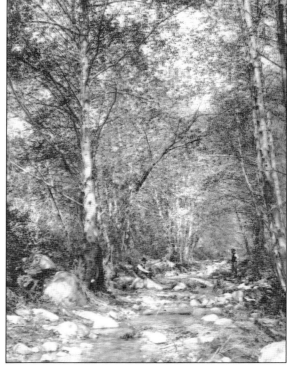

The Arroyo Seco, as it passed through Pasadena, varied from the wooded glades enjoyed by the fishermen at right to wide stretches of open valley floor, still visible today in the Hahamongna area close to the mountains. (Courtesy Pasadena Museum of History.)

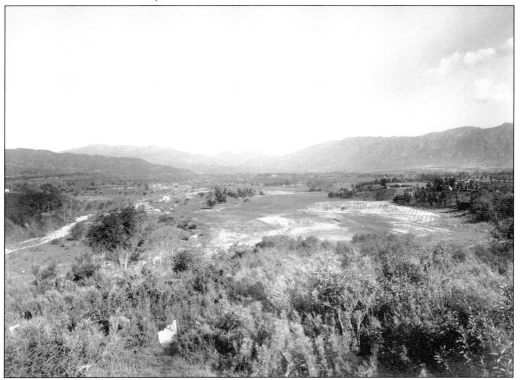

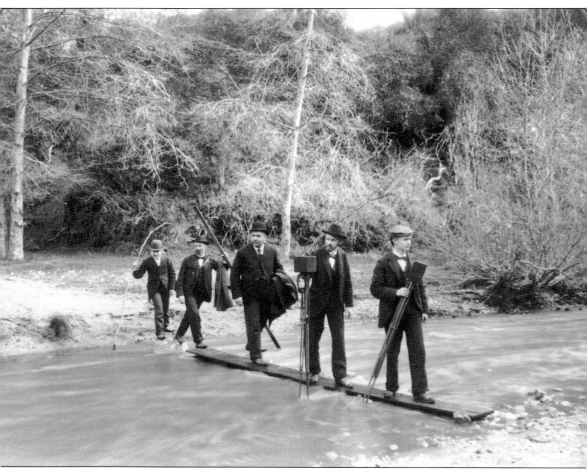

Adam Clark Vroman (1856–1916), well known as the founder of Vroman's Bookstore in Pasadena, was an artistic photographer who documented California and Southwest scenery and culture. He formed a group of camera buffs called the Club of Four; here they are, about 1897, crossing the stream in quest of subjects in the delightfully natural arroyo. (Photograph by A. C. Vroman; courtesy Pasadena Public Library.)

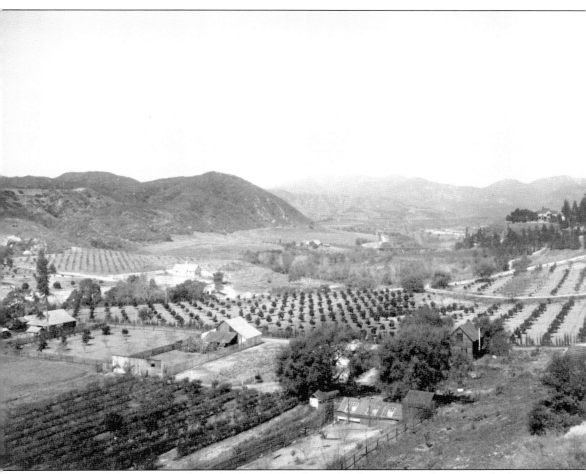

This photograph by Vroman, from the late 1880s, shows developments in the arroyo, looking north. Visible are orchards, vineyards, barns, and outbuildings. Just right of center, in the middle distance, is the West Pasadena Railway Company bridge to the Linda Vista area. (Photograph by A. C. Vroman; courtesy Pasadena Public Library.)

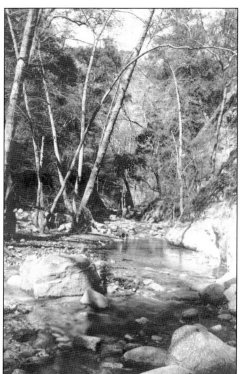

This is the effect—a harmony of rocks, trees, and stream—that modern restoration efforts in the Arroyo Seco will try to capture, at least in places. Pasadena historian Dr. Hiram Reid declared the arroyo was already greatly changed by 1895, as individuals had put up so many dams, bridges, retaining walls, private drives, and waterworks for their adjacent property. (Courtesy Pasadena Museum of History.)

The most dramatic changes of all were made by Adolphus Busch, who began in 1905 to develop his Busch Gardens on 30 acres behind his Orange Grove Boulevard mansion. His workers shaped and smoothed the wild arroyo into submission. The rolling lawns, storybook figures, paths, and pools became a nationwide tourist attraction. The gardens, shown here in 1909, closed in the late 1930s. (Courtesy Pasadena Museum of History.)

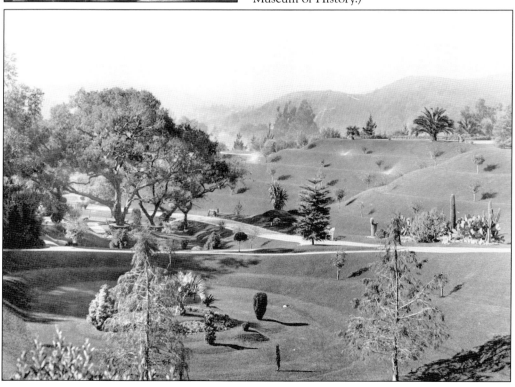

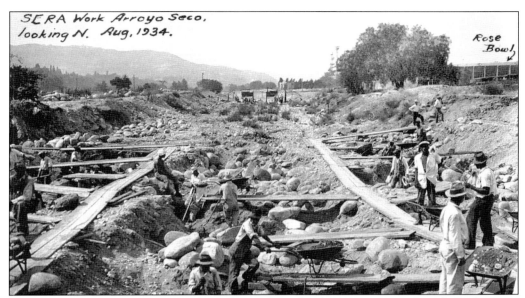

As the city grew, so did concerns about danger from flooding. In 1934, workers from the State Emergency Relief Administration (SERA) constructed flood control channels through the Central Arroyo. This view looks north and shows the Rose Bowl. (Courtesy Pasadena Public Library.)

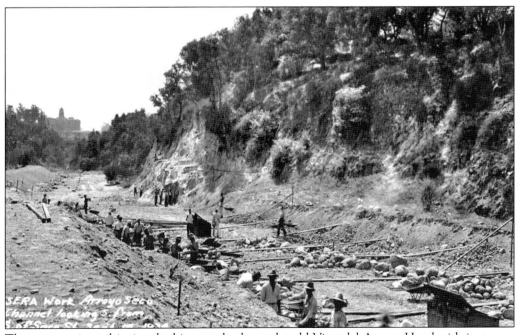

The same project, this time looking south, shows the old Vista del Arroyo Hotel with its tower. That landmark and highly visible building now houses a Federal Court of Appeals. (Courtesy Pasadena Public Library.)

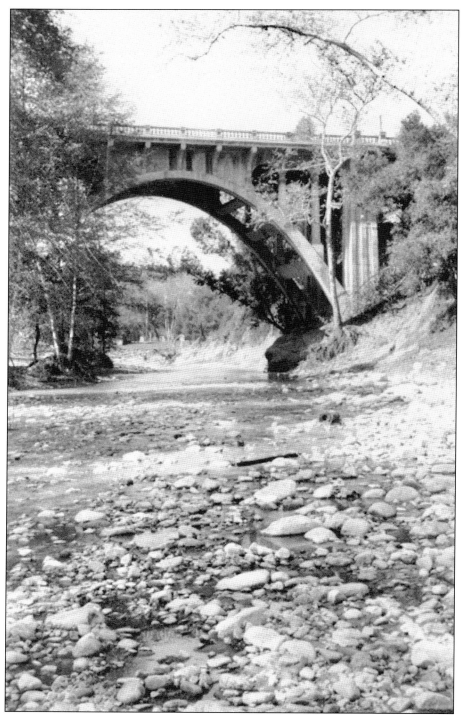

The arroyo topography lends itself to picturesque bridges over the natural stone riverbed. This one is the La Loma Bridge in a view taken in 1938. Its form echoes the much longer Colorado Street Bridge to the north. (Courtesy Pasadena Museum of History.)

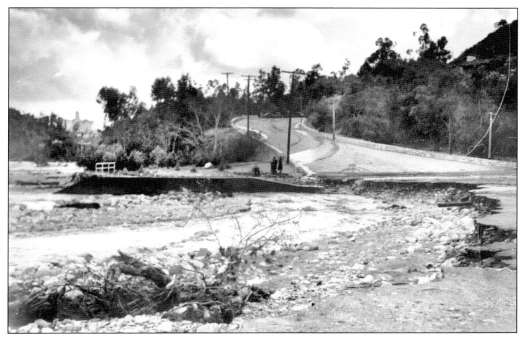

March 1938 saw monumental rainfall and flooding in Southern California. Here is the destruction that year of a road descending into the arroyo from the Linda Vista area. In the far distance at the left is the silhouette of the Vista del Arroyo Hotel, well above the waters on its high bank. (Courtesy Pasadena Museum of History.)

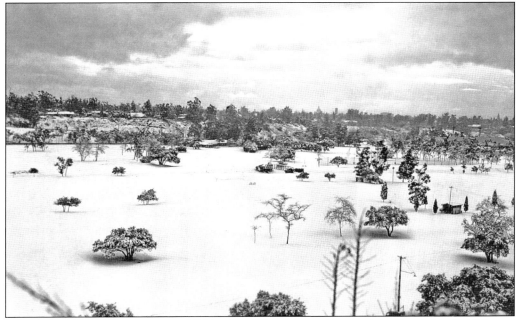

In January 1949, this surprise snowfall blanketed Pasadena and covered the Brookside Golf Course in the Central Arroyo. A tiny moon in the upper left seems dwarfed by the expanse of whiteness below. (Courtesy Pasadena Public Library.)

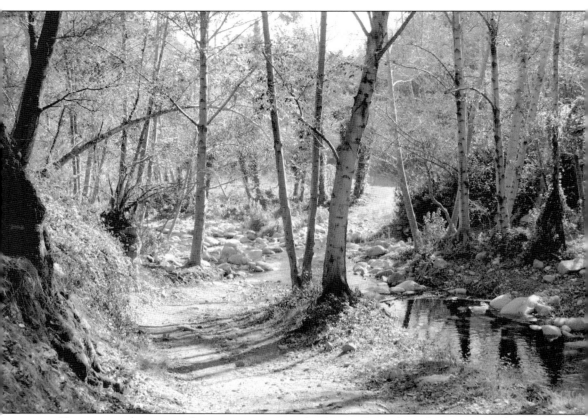

Here is a timeless scene of a stream crossing in the Arroyo Seco. At such spots, a Pasadena traveler could be in the 19th century or in this one. A goal of Arroyo Seco restoration is to re-create this experience along as much of the stream as possible. This modern photograph shows the upper reaches of the arroyo, but a similar wild stretch (not captured in a concrete channel) still exists under the Colorado Street Bridge. The arroyo has so much urban development close to its banks now that flood control concerns must be weighed. Even a stream as tranquil as this can reach flood proportions in rare years. (Photograph by Gabi McLean.)

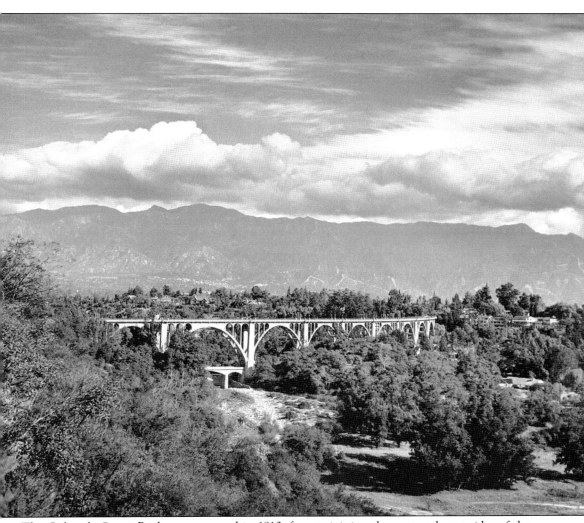

The Colorado Street Bridge was opened in 1913, forever joining the east and west sides of the arroyo. It was constructed in this graceful curve to take advantage of the soundest bedrock for its footing. A debate centered on whether it should be built at its present height or down in the canyon bottom; the present 160-foot level was chosen. Only one year after the natural barrier caused by the canyon was spanned, the Linda Vista and San Rafael neighborhoods became annexed to Pasadena. Today this gorgeous bridge, the rocky stream below, the cloak of urban forest, mountains beyond, and picturesque clouds form the city's iconic view. (Courtesy Pasadena Public Library.)

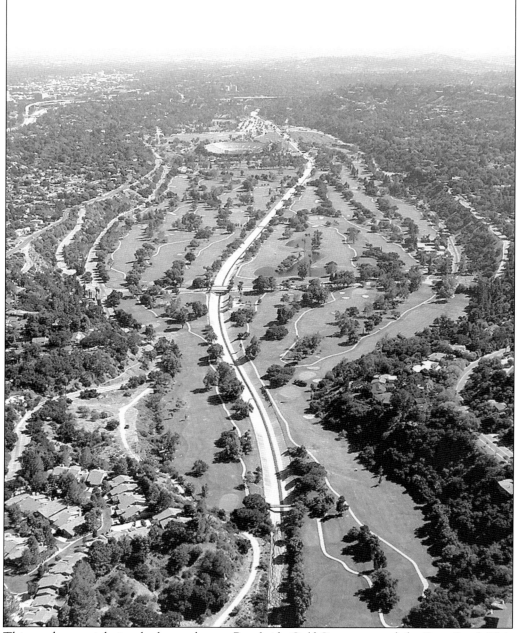

This modern aerial view looks south over Brookside Golf Course toward the Rose Bowl. This central section of Pasadena's arroyo has gone from its rough original state to an amazingly trim golf course. The stream is firmly in captivity in a concrete channel. The trees are planted in rows because of the fairways. Champions have played here since the 1920s. The bluffs along the side are densely rimmed with trees and houses, making a frame for the well-watered level golfscape. This section of Pasadena's once-wild heart, including the Rose Bowl and soccer and baseball fields, is given over to recreation, although other stretches of the arroyo remain more natural. (Photograph by Renee Strouse, Aerial Art Photography.)

Three

THE SAN GABRIEL MOUNTAINS

The San Gabriel Mountains may be called the foundation of Pasadena's natural history. This is because the rainfall they capture rushes downward to the valley, carrying the fractured rocks and gravel that become the well-drained soil of Pasadenaland and support the habitat of the plants and animals here. The earlier name for the range, the Sierra Madre or Mother Range, is worth remembering.

The San Gabriels stretch from Gorman in the west to Mount Baldy and the Cajon Pass in the east. They separate a coastal plain (essentially the Los Angeles basin) from the drier Antelope Valley and Mojave Desert. Behind the "front range," which makes such a dramatic backdrop immediately above Pasadena, layers of ridges rise higher and higher. Just a few miles behind the city (as the crow flies, longer on trail or by car) are peaks of 8,000 to 10,000 feet.

This gradient, or steepness, of the mother range accentuates the swiftness of the stream flows, depositing a rich depth of rocks and gravel in the basin below; witness the gravel quarries east of Pasadena and the "boulder architecture" of buildings all along the foothills. With earthquakes, the mountains may gain a few inches; then erosion wears them down again. An intensely wet year, though rare, may bring memorable debris slides.

Pasadenans were drawn to these mountains right away. Invalids sought the tonic air and rustic tent life. Families camped in mountain niches, bringing simple comforts along. Hunters, botanists, and artists all had their reasons to enter the mountains. The great dreamer Thaddeus Lowe carried people into the San Gabriels on his famed Mount Lowe Railway, which today seems a marvel of engineering in that precipitous and constantly shifting terrain.

In the 1910s and 1920s, hundreds of Pasadenans joined the great hiking era, staying in a network of simple mountain lodges. The era was swept away by the floods of 1938 but seems to be reviving today, as the mountains once again call city folk to walk into nature's realm.

The San Gabriel Mountains were a huge presence to villagers in the sparsely settled valley. This photograph by A. C. Vroman, which he titled "A Storm in the Mountains," gives them a prominence that is rarely noted today from Pasadena's high-rises and urban distractions. The view was taken about 1897. (Courtesy Pasadena Public Library.)

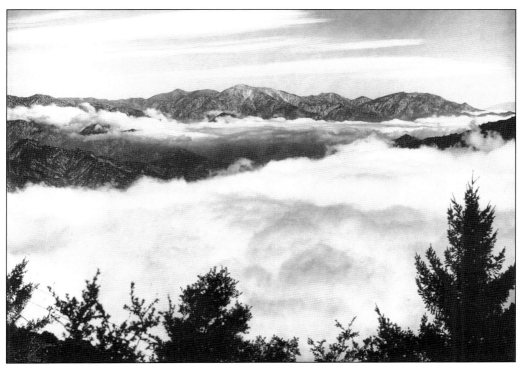

The layers of ridges are accentuated when clouds drift in between them. Hikers today are familiar with this effect, when the valley below, with all its cities, may be hidden and the mountain horizon stands out even more sharply. (Courtesy Pasadena Public Library.)

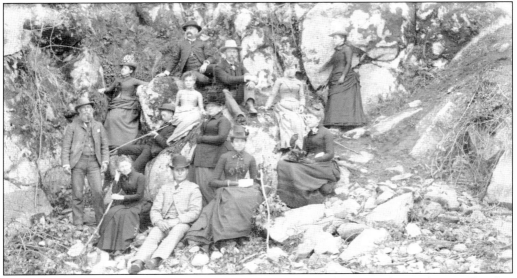

All those notches in the steep front range were an irresistible draw to early Pasadenans. Families flocked into the canyon openings for picnics. Each canyon had its stream outlet most of the year. This is the Rigg family at Devil's Gate in 1888, dressed for a special occasion it seems. They have arranged themselves in perfect harmony with the boulders. (Courtesy Pasadena Museum of History.)

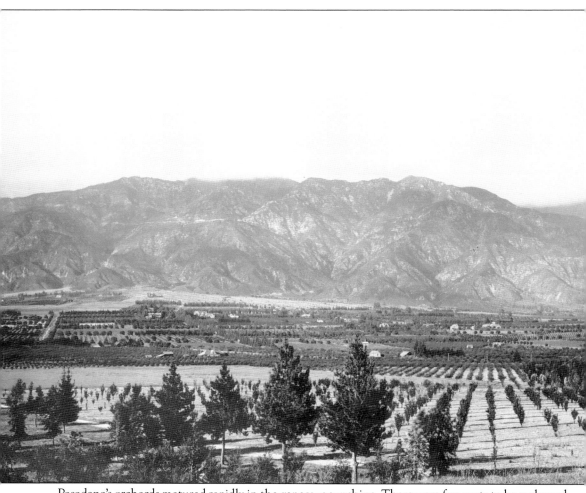

Pasadena's orchards matured rapidly in the generous sunshine. There were few pests to be reckoned with, other than the ever-present gophers. Historian Hiram Reid tells that Pasadena was plagued with grasshoppers in the early colony days, but the plowing year by year destroyed their eggs, and by the 1890s, they were no longer a problem. The mountains did harbor bears, which sometimes caused trouble with the canyon beekeepers, and mountain lions, which now and then raided the sheep corrals. (Courtesy Pasadena Museum of History.)

Rubio Canyon attracted the attention of Prof. Thaddeus S. C. Lowe, the inventor and financier whose mountain railway would become Pasadena's most famous attraction. Deep in the canyon, he built in 1893 a tourist pavilion below nine slender waterfalls. Walkways and over 1,000 steps threaded up the canyon for views of the falls, which had names like Roaring Rift, Moss Grotto, and Ribbon Rock. (Courtesy The Huntington Library.)

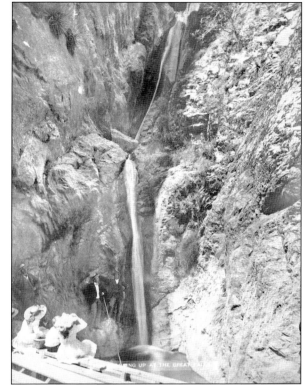

Professor Lowe (at left), ever the showman, welcomed his well-attired guests in the Rubio Glen. On special occasions, more than 2,000 illuminated Japanese lanterns glowed in the rocky gorge. (Courtesy The Huntington Library.)

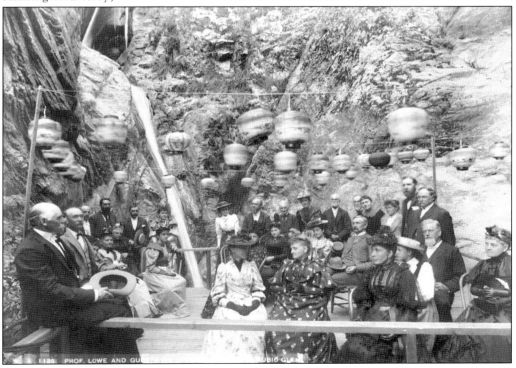

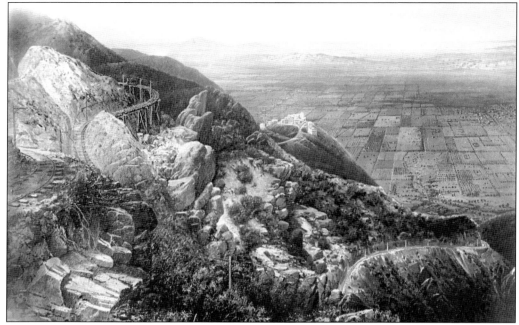

This painting shows the famed Mount Lowe Railway, which in its heyday rose more than 3,100 feet in elevation in just under 6 miles of track, from Altadena to the Alpine Tavern. This view shows the Circular Bridge and the Echo Mountain House, the first of Lowe's mountain hotels, completed in 1894. The railway was billed as "The Greatest Mountain Trolley Trip in the World." (Courtesy The Huntington Library.)

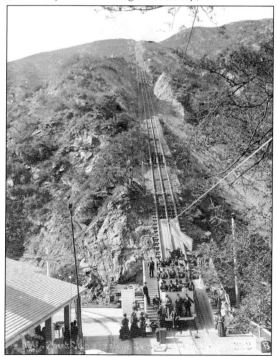

The Great Cable Incline was one of the most amazing engineering feats on the line. It rose from the Rubio Pavilion to Echo Mountain. Directed by chief engineer David Macpherson, workers graded the steep incline entirely by hand. A passing turnout was created midway so that ascending and descending cars could pass. The grand opening of the incline was July 4, 1893. (Courtesy The Huntington Library.)

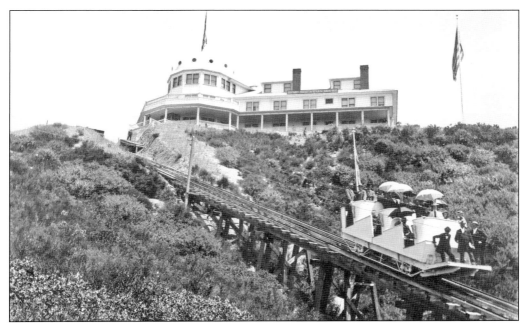

Here a car is reaching the head of the incline at the Echo Mountain House. This beautiful hostelry was destroyed by fire just six years later in 1900, but Professor Lowe had already pushed his line higher and built the Alpine Tavern. Today hikers can easily reach Echo Mountain by trail and see interesting relics there of the old railroad. (Courtesy The Huntington Library.)

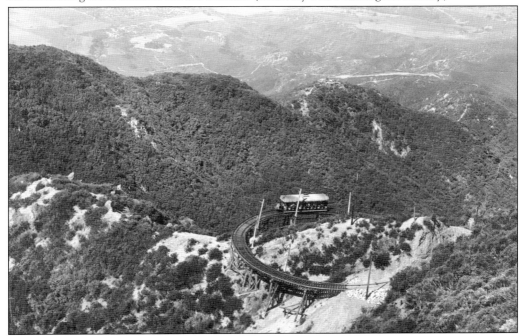

This is the Circular Bridge on the Mount Lowe Railway, which formed almost a complete circle with an ascending grade. Beside it was a sheer drop of about 1,000 feet. At this point, views appeared of the valley below, the sea, and Catalina Island. (Courtesy Pasadena Museum of History.)

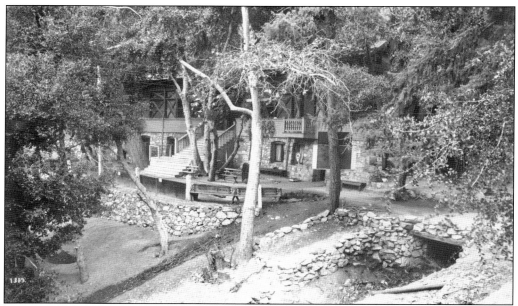

Travelers had now reached the end of the line at the Alpine Tavern, dedicated in December 1895. This destination was often snowy when Pasadena below basked among winter roses. The lodge was elegant yet rustic, using native boulders and built to accommodate large trees. But this hotel too was lost to fire, in 1936. Its site can be reached today by trails. (Courtesy The Huntington Library.)

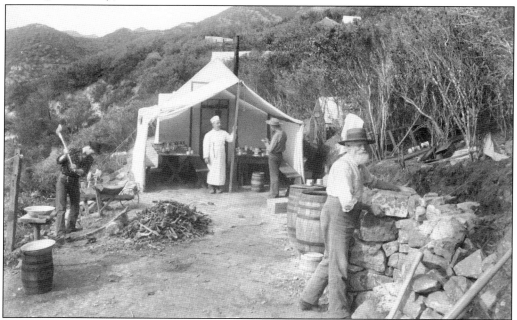

This is the workmen's dining tent on Echo Mountain during railway construction there. These appear to be challenging circumstances to be a chef. At right, with the white beard, is Jason Brown, son of the abolitionist John Brown. Jason and his brother Owen Brown came to live in the Pasadena foothills in the 1880s. (Courtesy The Huntington Library.)

In these aerial views, the homestead of Jason and Owen Brown appears remote and solitary in the hills above Altadena. Owen Brown was a survivor of his father's raid on Harpers Ferry and became well known in Pasadena. The brothers were drawn to the city for its progressive spirit and also because their sister had come to live there. They kept pack animals and occasionally served as local guides. The grave of Owen Brown is on a knoll on their former land, and nearby is Brown Mountain; these are in an area popular with hikers today. (Photographs courtesy Pasadena Museum of History.)

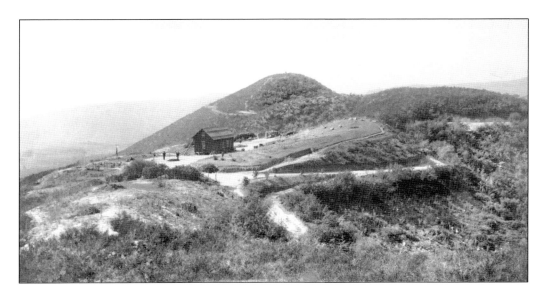

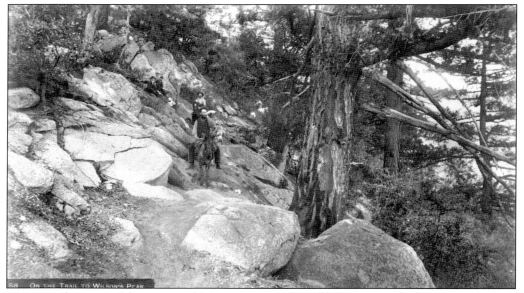

Many people ventured deeper into the mountains, not by rail but on foot or by horse or mule. Pack trains carried the necessities to distant campsites long before roads reached into the mountains. This route to Mount Wilson, with its huge boulders, barely appears to be a trail. Keeping and hiring out these sure-footed animals was a livelihood for some early Pasadenans. (Courtesy The Huntington Library.)

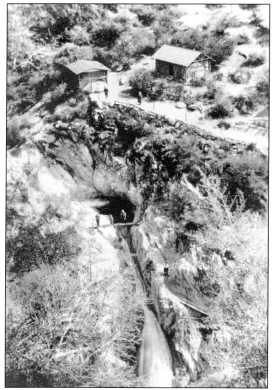

A favorite destination from the valley below was Switzer's Camp, established by "Commodore" Perry Switzer in 1884. Far up the Arroyo Seco gorge was his woodsy resort with cabins, tents, and a warm welcome. A traveler described reaching the camp by "shanks mare" or by "temperamental burro," covering a distance of eight miles on the trail from Altadena, with about 60 stream crossings. (Courtesy Pasadena Museum of History.)

50

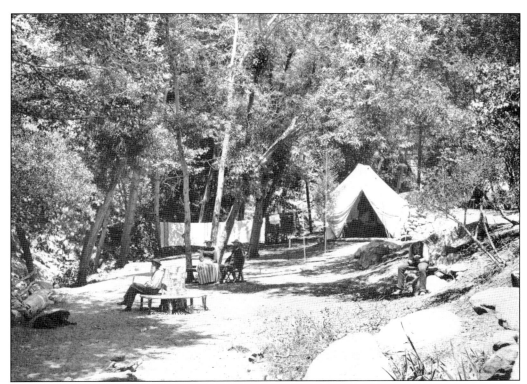

Life at Switzer's Camp was a respite from the town and offered fishing, hiking on nearby trails, or just sitting at peace. A later owner, Lloyd Austin, renamed the place Switzerland and added a tennis court, a library, and an open-air dance floor. The buildings are all gone now, but a shady public campground remains, reached by the Angeles Crest Highway. (Courtesy Pasadena Museum of History.)

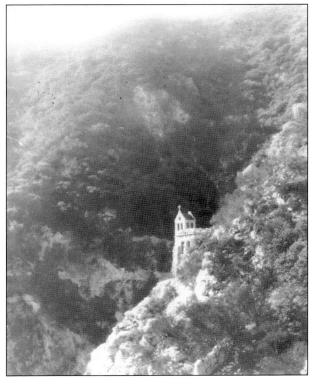

A beautiful little spot at Switzerland was the stone chapel, built by Lloyd Austin in 1924. It was designed by Arthur Benton, architect of Riverside's famed Mission Inn, and had an outdoor amphitheater seating 200. Its bell, stained-glass windows, and a small organ were all carried up the trail. Popular for many years, the tiny church was finally demolished after the resort was gone. (Courtesy Pasadena Museum of History.)

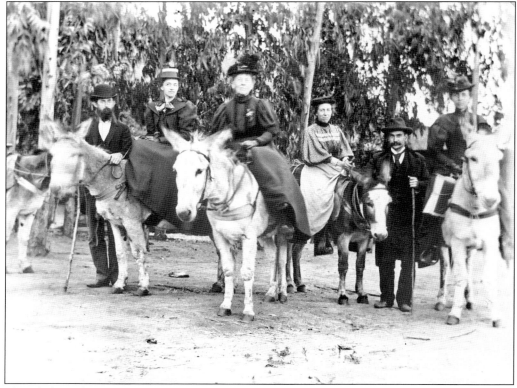

These ladies, riding sidesaddle on their burros, appear ready to embark on a day's outing into Pasadena's mountains or perhaps to sample a nearby canyon. (Courtesy The Huntington Library.)

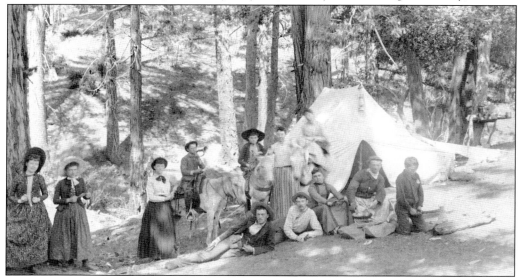

This is the Bunnell family, with their tent somewhere in the San Gabriel Mountains. Although Pasadena's climate was mild, early residents often resorted to a short mountain stay in the hottest months, sociably gathering family members and friends. (Courtesy Pasadena Museum of History.)

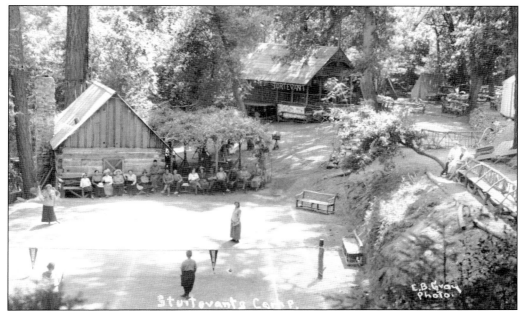

This postcard photograph, dated 1915, shows the tennis court at Sturtevant's Camp, a great favorite among the trail resorts in Big Santa Anita Canyon. Nettie, the sender of the postcard, writes her friend Hazel in Pasadena: "From here we're going to the top of Wilson this afternoon and come back by moonlight. . . . we hike, read, and play cards . . . Met some swell fellows yesterday." (Courtesy Pasadena Museum of History.)

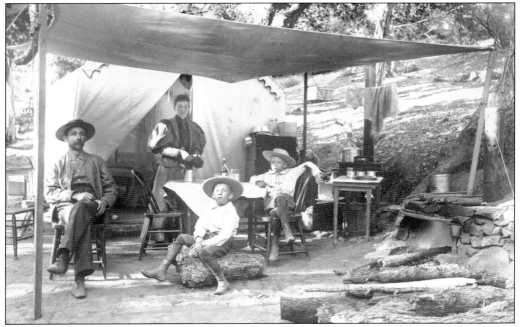

This family appears well settled into their mountain summer retreat. Some of the comforts of home are visible. With the assistance of the pack trains, an agreeable slice of life could be maintained in the forest for weeks on end. (Courtesy The Huntington Library.)

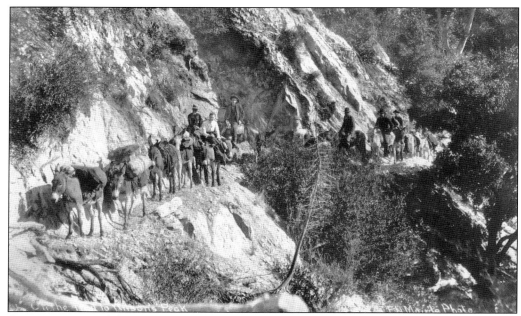

Getting to some of the more remote places by burro was not for the fainthearted. Several ladies are proceeding sidesaddle in this group, over a sliver of trail in crumbling terrain. The mountains were, and are, constantly decomposing. Trails like this needed frequent upkeep to remain passable. (Courtesy Pasadena Public Library.)

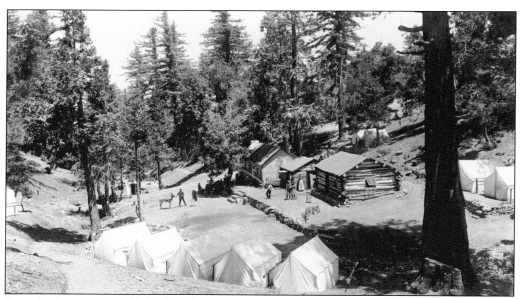

Strain's Camp was established in the 1890s in a grove of sugar pines just below the summit of Mount Wilson. It had a year-round spring, log cabins, and rows of neat tents for a mountain sojourn. Swinging in hammocks was a favorite pastime, or tramping out to nearby peaks. (Courtesy Pasadena Museum of History.)

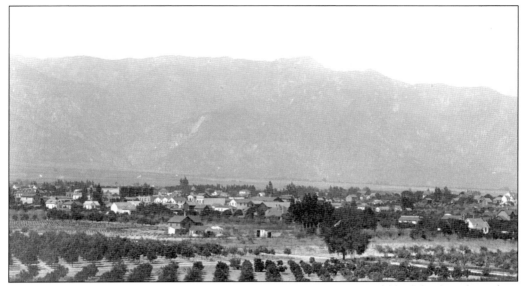

Returning from a refreshing stay in the high country, Pasadenans could look back and see their mountain range once again as a backdrop—but now they knew some of its secrets. (Courtesy Pasadena Museum of History.)

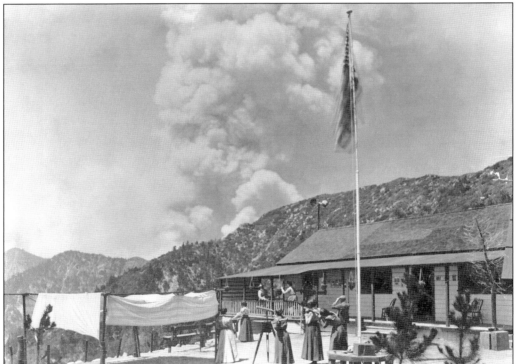

From Martin's Camp, also near the summit of Mount Wilson, visitors watched this spectacular mountain fire in 1898. The trail resorts and lookout places in the mountains were commonly equipped with telescopes to survey the scenery or to look toward the town below. (Courtesy Pasadena Museum of History.)

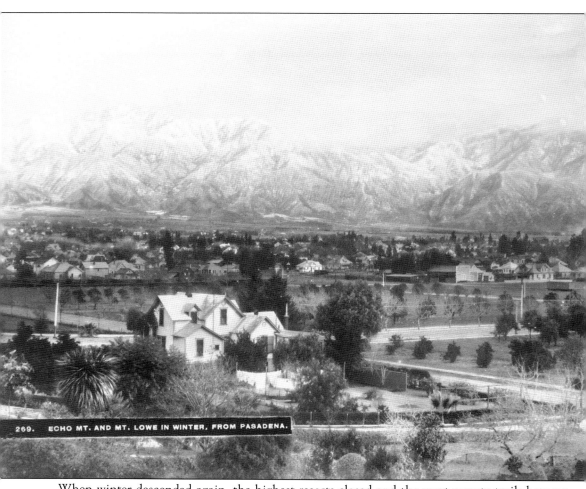

269. ECHO MT. AND MT. LOWE IN WINTER, FROM PASADENA.

When winter descended again, the highest resorts closed and the most remote trails became impassable until another spring in the mountains. (Courtesy The Huntington Library.)

Four

CANYONS AND EDGES

Naturalists love edges because these transitional areas (known as ecotones) contain creatures native to both the adjacent zones. There is a richer diversity of life where forest meets open grassland or a stream is beside a sunny slope.

For the earliest settlers in Pasadena, life was in a sense constantly "at the edge." Just beyond their cleared land was wild nature. Rattlesnakes, tarantulas, and horned toads came and went, and gophers were all too familiar.

As the cultivated lands expanded, the wild creatures retreated. But there were always areas to explore beyond the town. The mouths of canyons were just above the orchards of Altadena, cool sanctuaries for summer picnics. Among the favorite spots were Millard's Canyon and Devil's Gate.

On the eastern side of Pasadena, a picturesque stream rushed out of the mountains, carrying boulders in the rainy season. The early ranchers named the canyon "El Precipicio" for its steep walls. Half a mile into this mountain fastness was a beautiful waterfall, another picnic haven, which John Muir visited in 1877, calling the spot "a little poem of wildness."

In 1865, before the Indianans arrived, Judge Benjamin Eaton had settled into the Fair Oaks Ranch just west of this canyon (borders of the ranch were present-day Altadena Drive, Washington Boulevard, Allen Avenue, and New York Drive). This was the idyllic spot visited by Daniel Berry in 1873, which convinced him to bring his party to establish Pasadena.

Eaton became illustrious for planting more than 30,000 grapevines that thrived without irrigation. Somehow he had found the critical edge between agriculture and the native climate. Later he became known for conveying water to the new settlement. In time, the sweeping wash beside his land was called Eaton Canyon.

Today Eaton Canyon Natural Area is a Los Angeles County Park and an ideal place to study nature's edges. Various plant communities intersect as the land rises sharply in tributary canyons. The 19th-century homesteaders of the area are long gone, and now the park is a natural sanctuary for all visitors.

For some of the early colonists, home was not "in town" but out on the edges, like this simple homestead in the foothills. People came to Pasadena to invest in land and make a cultivated society, but people also came with illness or to leave behind a regrettable past. For these, an isolated spot had its virtues and the sunny climate gave hopes for a better future. (Courtesy Pasadena Museum of History.)

Abbot Kinney, already a millionaire, came to Pasadena for his health in 1880. He bought 500 acres of the land shown here, a dry mesa just east of Eaton Canyon. He created a ranch of vineyards and fruit groves, called Kinneloa, which was like a country estate. Later he developed Venice, California, and was a strong conservationist. Today houses cover the Pasadena neighborhood still known as Kinneloa. (Courtesy Pasadena Museum of History.)

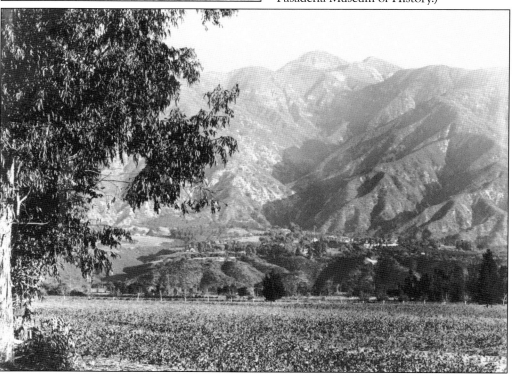

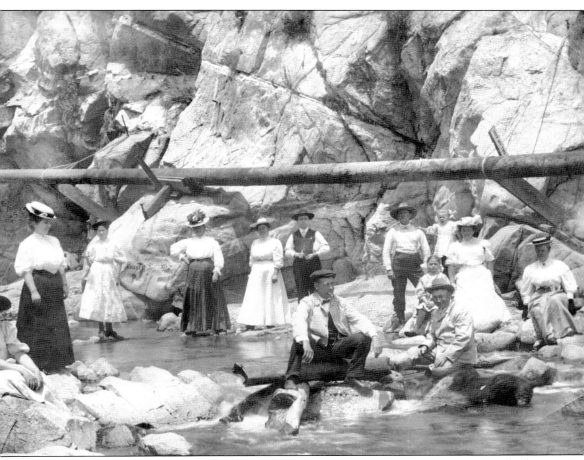

Canyons held the promise of water in the early, agricultural years. This group may have had something to do with the waterworks and piping visible in this photograph of an unidentified rocky gorge. This is not a working group, but perhaps they have brought family to show off the success of some horizontal tunneling that yielded a vigorous flow to fields below. Questions of boundaries, titles, ownership of springs, and the like occupied the colonists, sometimes fiercely, until at last water allocation principles were set up. Today hikers in any canyon of the front range can see vestiges of the old systems and pipes. (Courtesy Pasadena Museum of History.)

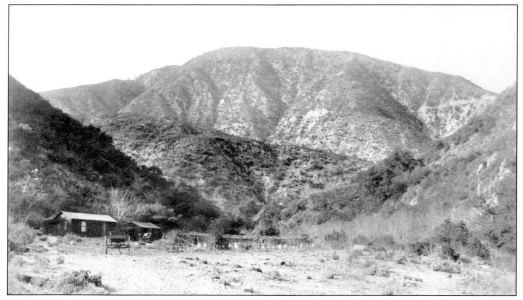

Beekeeping was a needed occupation, and some early memoirs mention this work as a way to tide a family over in unfavorable harvest times. This foothill apiary seems the abode of one of the solitary settlers. Beekeepers moved their hives as needed. (Courtesy Pasadena Museum of History.)

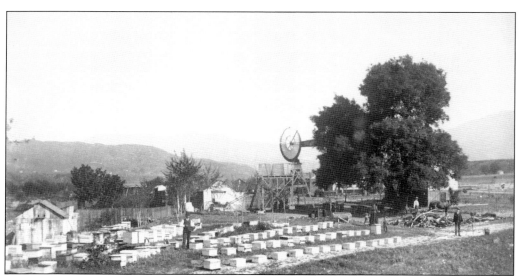

This property is identified as Schleismayer's Home Apiary. There are telling details: the neat rows of white hives, a family apparently with two small children, even a child's rocking horse just in front of the buggy. They had their own well, and an orchard behind and to the left. The man on the right appears to have a camera and tripod. This was a substantial country household. (Courtesy The Huntington Library.)

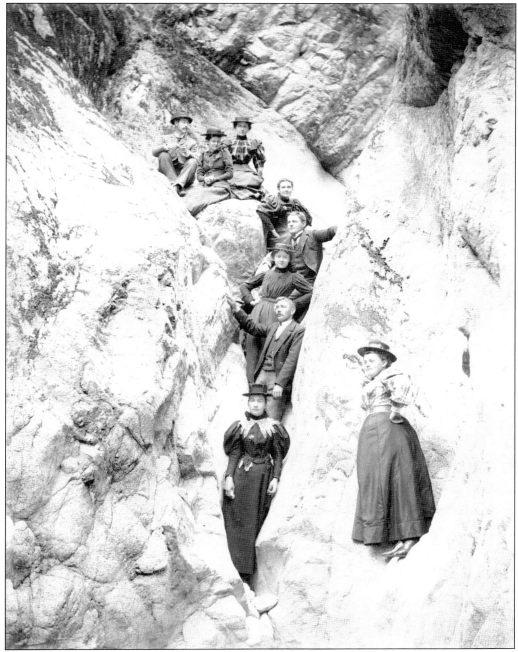

On their outings, Pasadena ladies had a special talent for arranging themselves artfully in the natural settings, but never, perhaps, more adroitly than this. (Courtesy Pasadena Museum of History.)

This is Rubio Canyon Pavilion, photographed at a scale that accentuates the grandeur of the mountain and the smallness of the building. It was the starting point for Professor Lowe's Great Cable Incline. Although the pavilion held a dance floor and dining room for 80 diners, it is not surprising that it was severely damaged at times; storms and rockfalls often rushed through such narrow canyons. (Courtesy Pasadena Museum of History.)

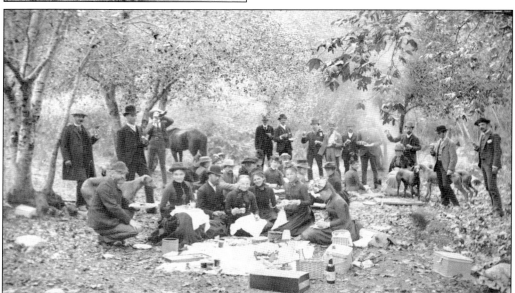

Millard Canyon, shown here in 1888, was named for a man who homesteaded at the canyon mouth in the 1860s, raising bees and cutting wood. After he departed, the Giddings family acquired the land and built a wagon road up to the 60-foot Millard Canyon Falls, one of the loveliest spots on the mountain edge. This accessible haven became a favorite picnic spot. (Courtesy Pasadena Museum of History.)

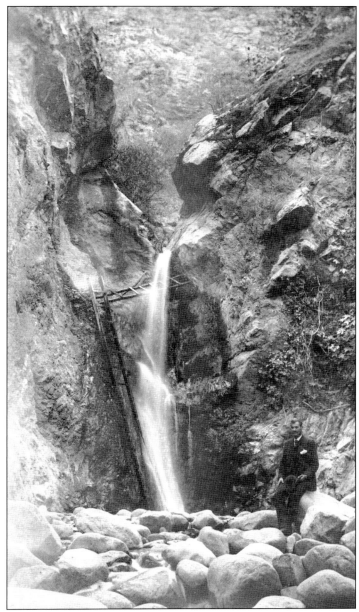

The 40-foot-high Eaton Falls is at the heart of Eaton Canyon, so named for Judge Benjamin Eaton, who developed his Fair Oaks Ranch on its western edge. The canyon is the outlet for a great watershed of high peaks beyond it in the mountain range. Below the falls, the canyon opens out into a wide natural wash of rocky streambed, oak woodland, and meadows—today a 190-acre county park. Above the falls are nearly perpendicular rock walls. In the upper canyon, a famous pair of California condors nested in 1906 in the only condor nest known in the San Gabriel Mountains. Herman Bohlman and William Finley (a friend of Theodore Roosevelt) reached the nest and took more than 250 photographs. Modern ornithologists visited the Finley-Bohlman site, using ropes to get down the cliff, and found the old eggshells. Condors were resident in the San Gabriel Mountains from 1890 to about 1910. (Courtesy Pasadena Museum of History.)

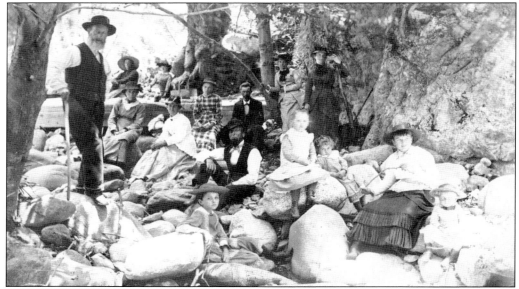

As seen by this view of 1879, Eaton Canyon was enjoyed as a picnic spot. This photograph was taken just five years after the Indiana Colony settlers had arrived, but Judge Eaton had been in the area longer. He moved near the canyon in 1865 and entered a contract to bring its waters out for agricultural use. (Courtesy Pasadena Museum of History.)

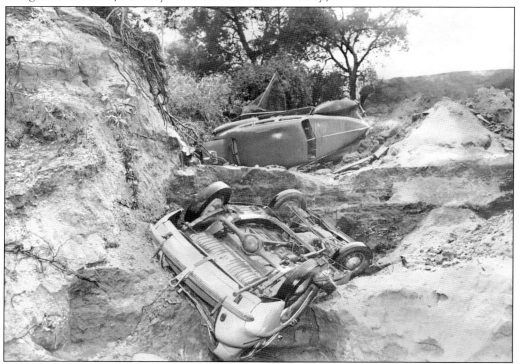

There is no denying the force of waters rushing out of Eaton Canyon in sudden heavy rains. These cars were storm-tossed in the canyon in 1943. Other flood times have toppled old oaks and cut even wider and deeper edges to the wash. (Courtesy Los Angeles Public Library.)

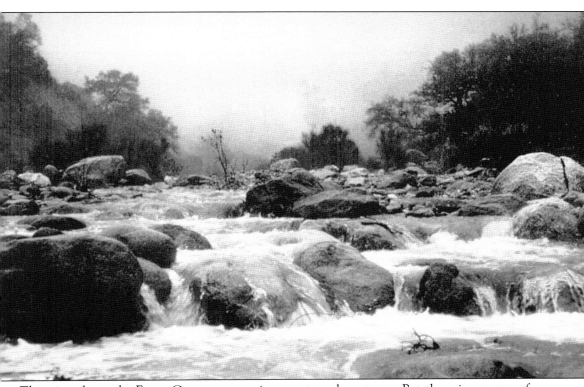

This view shows the Eaton Canyon stream in an extremely wet year. But the rainy season of 2006–2007 has been the driest ever recorded, with less than three inches of rain for the season in Pasadena. (Photograph by Arden Brame.)

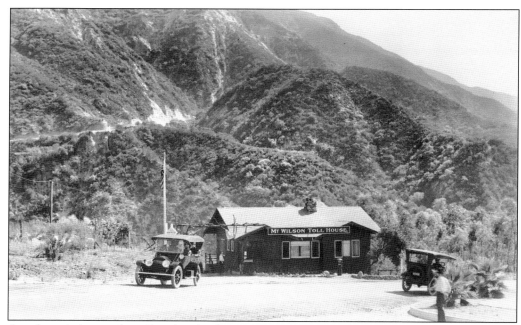

Another vital route from Pasadena's edge was up to Mount Wilson, where George Ellery Hale had established the Mount Wilson Solar Observatory in 1905. This tollhouse for the road, shown here in 1914, was on the west side of Eaton Canyon. Beyond it, the road led up to Henninger Flats and on to the mountain summit. (Courtesy Pasadena Museum of History.)

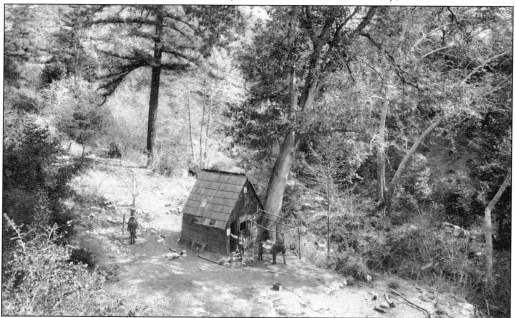

A trail rising up Little Santa Anita Canyon was another way up to Wilson's Peak. This first modern trail into the San Gabriels was constructed by workers for Don Benito Wilson in 1864 for access to timber. Here is the old Half Way House for that work project. (Courtesy Pasadena Museum of History.)

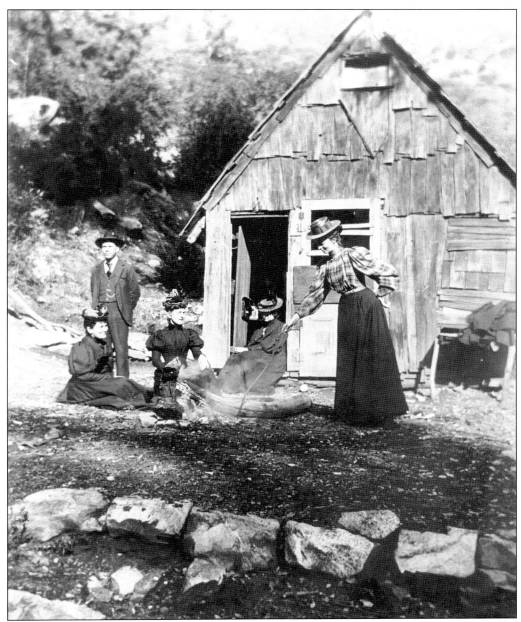

Wilson's trail became a popular trek in the 1880s and 1890s. These ladies are tending a fire outside the Half Way House about 1890. In the years before 1880, a Canadian named George Islip occupied the little cabin briefly, planting fruit trees and keeping bees. He sent the honey and also wood shingles down to the valley by burro. Later the site became known as Orchard Camp, the name it retains today. All buildings there are gone, but the spot is a wonderful haven for city-weary people as it has been for years. (Courtesy Pasadena Museum of History.)

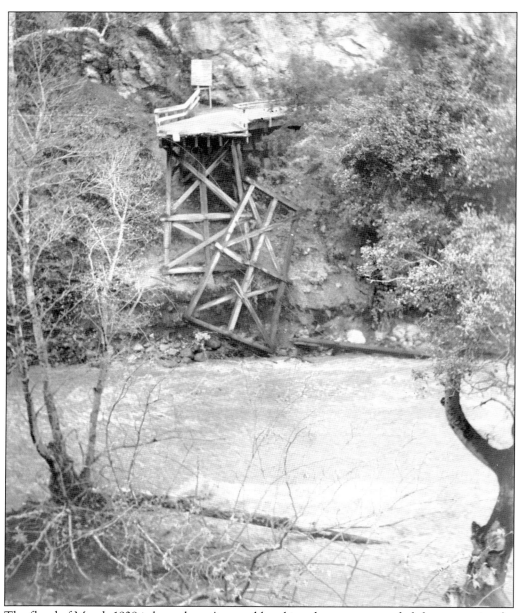

The flood of March 1938 is legendary. A record-breaking downpour pounded the mountains for two days and destroyed most of the old historic camps. The flood reduced to twigs this bridge on the Mount Wilson Toll Road, just where the Eaton Canyon stream emerges from the mountains. Following that disaster, many of the flood control projects now confining streams in the San Gabriel Valley had their start. (Courtesy Pasadena Museum of History.)

Along Pasadena's western edge, the San Rafael hills separated the Pasadena colony from Garvanza (today's Highland Park) and Los Angeles. In 1876, Prudent Beaudry built this tunnel for a wagon road to pass to the west. At 480 feet long, it was framed with heavy planks but subject to cave-ins. It was dismantled about 1923, and the cut is now Burleigh Drive. (Courtesy Pasadena Museum of History.)

One of the great natural curiosities much visited by Pasadenans was the Eagle Rock. This weather-beaten landmark was about three miles west of the colony, in a neighboring valley with its own settlement. The west side of the rock is about 150 feet high, with an overhanging brow resembling the wings of an eagle. Early equestrians often rode there and back for a day's outing. (Courtesy Pasadena Museum of History.)

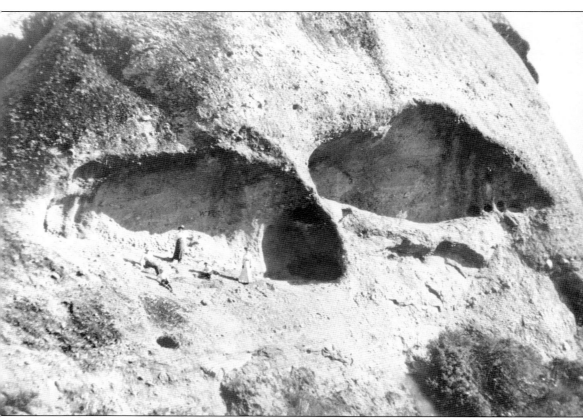

In this view, probably from the 1890s, people are exploring the caves of the Eagle Rock. The lower cave was reached by a difficult climb; the upper one was considered inaccessible, although youthful adventurers liked to attempt it. It was reported that an old French beekeeper lived for a time in the lower cave. (Courtesy Pasadena Museum of History.)

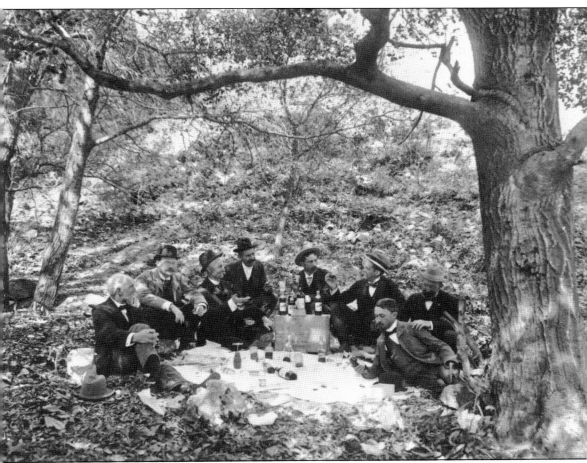

Perhaps the ultimate of the many vintage picnic photographs is this one, "Lunch in Millard Canyon," from the 1890s. The photographer, A. C. Vroman, lounges comfortably at the right, with his photography club and their friends. The eight gentlemen have clearly sampled and finished several bottles of wine and seem to be discussing the virtues of a red. The crate in the center is labeled "Hotel Green, Pasadena," one of the city's finest resort hotels. (Courtesy Pasadena Public Library.)

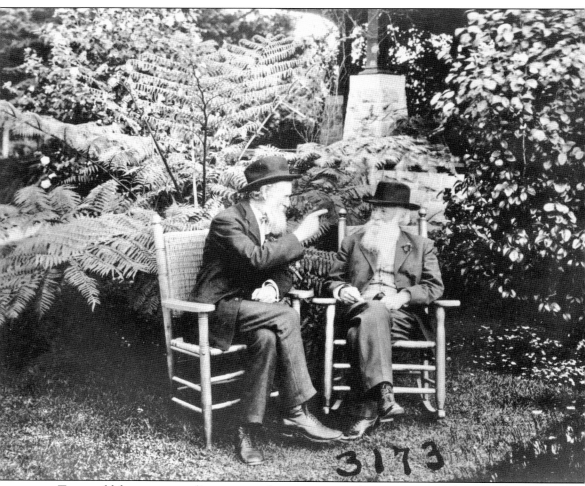

Two world-famous naturalists are seen here in animated conversation: John Muir (1838–1914) at left and John Burroughs (1837–1921) at right. The two friends were in Pasadena Glen, where Burroughs had a little bungalow called the Bluebird toward the end of his life. The date is perhaps 1911, when they had both been present for Theodore Roosevelt's visit to Pasadena that year. Muir had a long association with Pasadena, having come first in 1877 to visit Ezra and Jeanne Carr, friends from his Wisconsin days. He explored Southern California forests and deserts and made a memorable trip into rugged Eaton Canyon. Burroughs was primarily a naturalist of the East from his rustic home called Slabsides on New York's Hudson River. The two men each wrote many books and influenced a developing conservation ethic in the country. In their day, Muir was known as "John of the Mountains" and Burroughs, "John of the Birds." (Courtesy Department of Special Collections, University Research Library, UCLA.)

Five

WATER

In 1888, the state engineer of California published his study of irrigation in Southern California, including Pasadena. He described the town's main water sources in the Arroyo Seco. Geologically the canyon is a deep gravel-filled gorge, crossed by several bedrock ridges. The arroyo stream flowed from the mountains, above ground or below it in dry times. But the waters were thrown to the surface as they reached several obstructions of bedrock.

The first of these was at Devil's Gate. The opening (with a rock formation resembling a devil's profile) was a gap some 70 to 80 feet deep and at one point only 30 feet wide at its bottom. Above Devil's Gate was a great gravelly basin, now called Hahamongna Watershed Park. Just above and below the rocky gateway were a group of springs critical to the early settlers of Pasadena: Thibbets, Ivy, and the Flutter Wheel Springs.

Farther downstream, the waters encountered another bedrock ridge (under the present Colorado Street Bridge) and again came to the surface. Here the Sheep Corral Springs arose under the hillside now behind Brookside Park. Wherever the waters emerged, they were diverted and piped out to the new settlement for irrigation or domestic use.

Eaton Canyon was another early water source. Tunneling had begun there in 1866, and flumes carried the water to reservoirs at the Crank, Brigden, Craig, and Allen ranches east of the town center.

Water lay under the city of Pasadena then, as now, in a large underground basin accessible by wells. Also springs and marshes were tapped along Pasadena's southern border, where water flowed from the bluffs still visible below Raymond Hill, Oak Knoll, and The Huntington Library grounds.

In 1895, historian Hiram Reid listed 10 water companies in and around Pasadena. Tunneling, boring, and piping were proceeding at a great rate. Controversies and complicated agreements marked the development of this vital resource for the young city.

Now the native landscape is much altered, especially by the massive Devil's Gate Dam of 1920. Today Pasadena uses a combination of its own groundwater and imported water from the Metropolitan Water District.

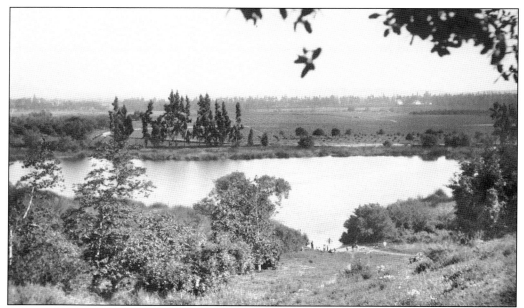

A beautiful feature of early Pasadena was this lake, called Mission Lake then Wilson's Lake. It was fed by natural springs gathering in a hollow below the sharply rising hills of Oak Knoll on Pasadena's southern border. "One of the fairy spots to be met with so often in California," wrote a 19th-century traveler. Today this spot, with its 12-acre lawn, is Lacy Park in San Marino. (Courtesy Pasadena Museum of History.)

In 1816, this gristmill was built for the San Gabriel Mission. El Molino Viejo, or the Old Mill as it is known today, used a stream in one of the canyons descending from Pasadena toward Wilson's Lake (shown in the background). The Old Mill later served as a residence for 100 years and today can be visited as a mellow historical treasure. (Courtesy The Huntington Library.)

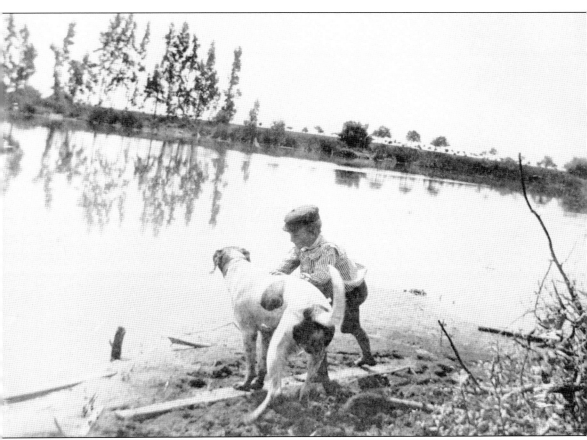

A glimpse of a long-ago childhood can speak volumes. This photograph is labeled simply "Rufous and his dog Dan." They are enjoying Wilson's Lake, which by 1900 had become a boggy swimming hole for local children. Young George Patton, the future general, lived on a nearby hill and recalled a raccoon outwitting pursuing dogs by swimming to a floating stump in the lake. But irrigation and later housing development finally reduced the picturesque lake to mud. In the 1920s, the City of San Marino acquired the property for a park and brought in fill dirt from excavations for Caltech buildings in Pasadena. The old lakebed was leveled, and with the help of Henry Huntington's horticulturalist, William Hertrich, the former bog became Lacy Park. Walking today along its great lawn, one finds it easy to imagine the park's watery past. (Courtesy Pasadena Museum of History.)

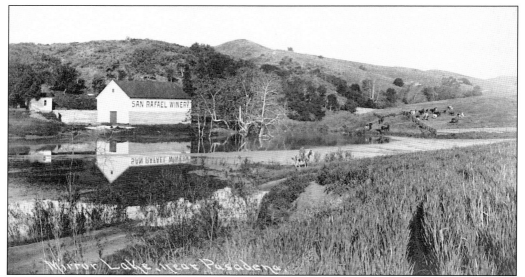

Another indication of the abundant waters in Pasadena's early years is Johnston Lake. This small, stream-fed valley is in the San Rafael Hills west of the Arroyo Seco, and its flow joins the arroyo stream. Prudent Beaudry constructed this winery sometime around 1875, during the ranching years. Today a vestige of the lake remains among private homes. (Courtesy Pasadena Museum of History.)

Easy to visit today is Baldwin's Lake, now part of the Los Angeles County Arboretum in Arcadia. The lake is basically a *cienega* or a perennially wet area on the earthquake fault along Pasadena's southern border. E. J. "Lucky" Baldwin developed the vast Rancho Santa Anita next to the Pasadena ranches, and his lake was a famous beauty spot for the early settlers to see. (Courtesy The Huntington Library.)

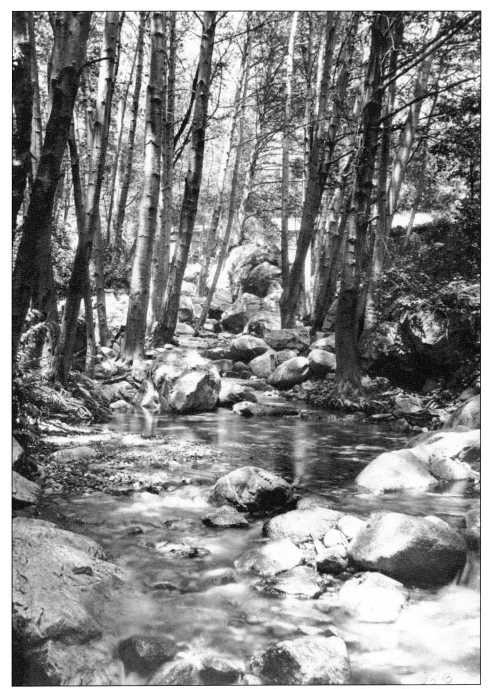

The theme of water was repeated often in the canyons descending from the San Gabriel Mountains. This scene shows a tranquil stretch of trail, pleasant for a saunter or a picnic. But as the waters gathered force and emerged from canyon mouths, they became a vital necessity in the agricultural days. Every canyon had its claims or water company, and the politics of 19th-century Pasadena had much to do with adjudicating the precious resource. (Courtesy Pasadena Museum of History.)

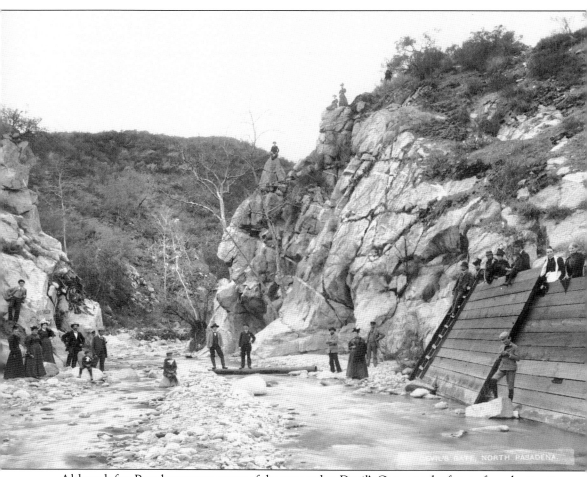

Although few Pasadenans are aware of the spot today, Devil's Gate was the focus of much attention from the colonists. The springs at this dramatic gorge yielded the first waters for irrigation and starting the town. By the 1870s, Judge Benjamin Eaton had three miles of pipe connecting Devil's Gate and the reservoir near today's Walnut Street and Orange Grove Avenue. Another pipeline ran from there south on Orange Grove. Studying irrigation patterns in 1888, the state engineer, William Hamlin Hall, found the Arroyo Seco area to be "a vast deposit of boulders, gravel, and sand," with ample water flowing either on or below the surface. In addition, Devil's Gate satisfied the 19th-century delight in sublime and picturesque scenery: these visitors have reached some precarious heights at the famous rocky gap. (Courtesy Pasadena Museum of History.)

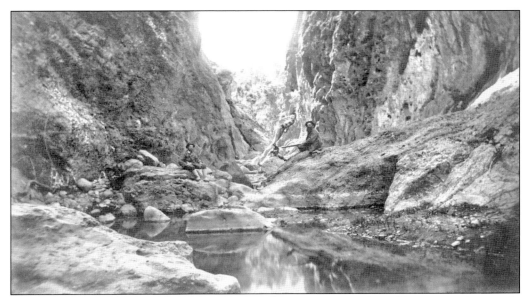

This is another view of Devil's Gate, with three hunters pausing there. Hunting in those early days of Pasadena was both a sport and a way of protecting the fledgling town and farms from predators. Mountain lions and bears were reported to be common in the canyons, and they sometimes ventured too close to homes and corrals. (Courtesy Pasadena Museum of History.)

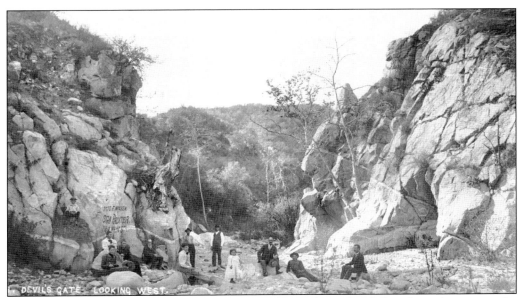

Devil's Gate is said to be named for the devil's profile in the rocky cliff, perhaps the one on the right here. Historian Hiram Reid in 1895 reported that the place was named by Judge Benjamin Eaton in 1858 for resembling a point by that name on his route along an old trail into California. Place names do evoke different tales. (Courtesy Pasadena Museum of History.)

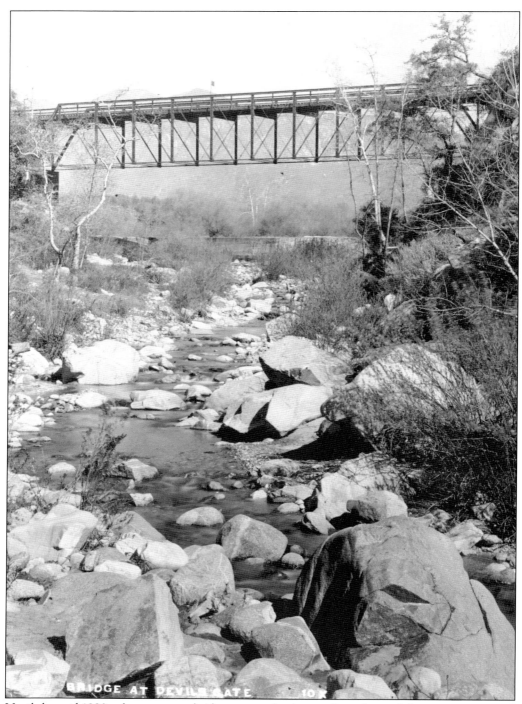

BRIDGE AT DEVILS GATE 10 K

Until the mid-1880s, there were no bridges across the Arroyo Seco. Instead the crossing required driving one's horses steeply down a narrow road, through the stream, and up the steep bank on the other side. The bridge shown here was constructed across Devil's Gate and remained in place until construction of the dam. (Courtesy Pasadena Museum of History.)

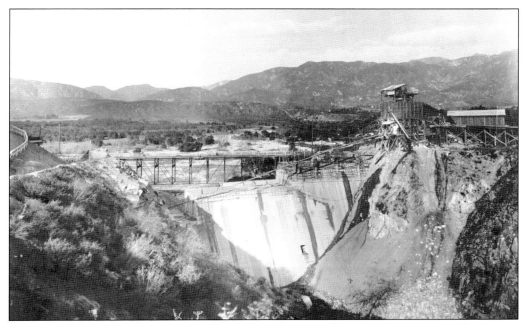

The building of Devil's Gate Dam made a drastic change in the natural character of the Arroyo Seco. The rainbow trout disappeared, and wildlife dependent on the free-flowing stream had their habitats greatly altered. The old, natural springs were subsumed into the controlled water system of a dam and spillway. (Courtesy Pasadena Museum of History.)

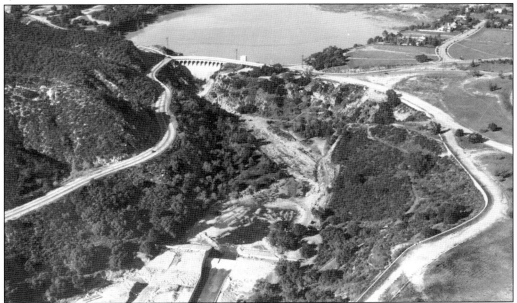

The dam was dedicated in 1920. Later photographs and road maps showed a beautiful lake behind the dam, but this is now gone. Reinforcements to the dam in the 1990s improved its earthquake stability, but water is no longer allowed to accumulate there. Some gravel mines on the lakebed have departed, and the city will create Hahamongna Watershed Park, a primarily natural area, on that site. (Courtesy Pasadena Museum of History.)

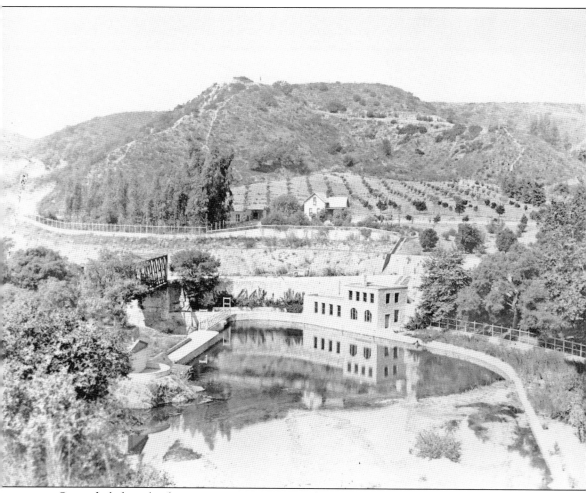

Some feel that the first major incursion into the natural beauty of the Arroyo Seco was the construction of the Scoville Dam, Bridge, and water works in the 1880s. This complex was at the spot now crossed by the Colorado Street Bridge. The wealthy Scoville family used its pump house to send water to its orange groves on the nearby hills. The Scoville Dam soon became ineffective because it filled so quickly with gravel and sand. However, the Scoville Bridge was an important crossing until the Colorado Street Bridge was built in 1913. Remnants of this Scoville infrastructure can still be seen under the Colorado Street Bridge. (Courtesy Pasadena Museum of History.)

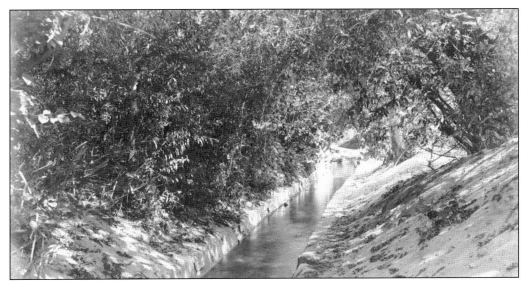

Miles of stone-lined *zanjas*, or ditches, like this one, crisscrossed the San Gabriel Valley in the agricultural years. *Zanjeros*, or ditch-tenders, kept them free of rock slides or dead animals so the water would flow. Networks of side ditches carried the water to individual furrows in the groves. These systems were basic aspects of Pasadena's agricultural life. (Courtesy Pasadena Museum of History.)

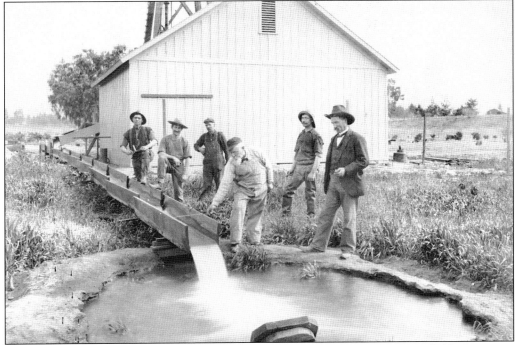

Box flumes like this one conveyed water from individual wells or canyons to fields or storage reservoirs. From Eaton Canyon, for example, flumes carried water to the reservoirs of the Brigden, Craig, and Allen properties. All of these early ranches are remembered today in street names of east Pasadena. (Courtesy Pasadena Museum of History.)

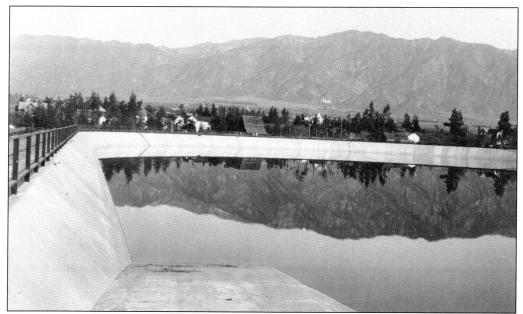

As Pasadena grew, more reservoirs were established in other parts of the city to serve the increasing residential needs. These pictures show the Villa Street Reservoir, which was located at the north end of Euclid Avenue at Villa Street. It was active for several decades in the mid-20th century. In 1973, the city acquired the land, and today the large open space holds the Villa Parke Neighborhood Park and Community Center, one of the largest Pasadena parks. There are still two active wells of the Pasadena water system on the site. The park is also home to one of the favorite farmers' markets in this area. McDonald Park in Pasadena's Bungalow Heaven neighborhood was also once an active reservoir, the Wilson Reservoir. Abandoned for water purposes, the site there was converted into parkland in the 1970s. (Courtesy Pasadena Museum of History.)

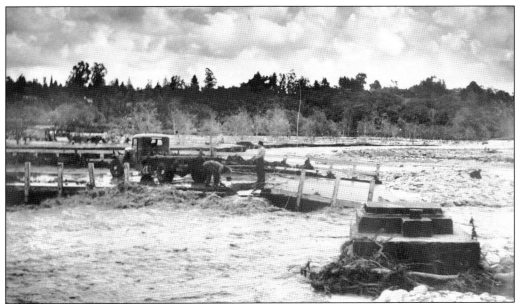

The disastrous flooding of March 1938 wrecked almost anything built near Southern California's waterways, especially in the San Gabriel Valley. This damaged bridge at Brookside Park in the Arroyo Seco shows the force of this greatest of all Pasadena floods. Between 1934 and 1947, much of the arroyo stream was lined with concrete, a drastic change for the sake of future flood safety. (Courtesy Pasadena Museum of History.)

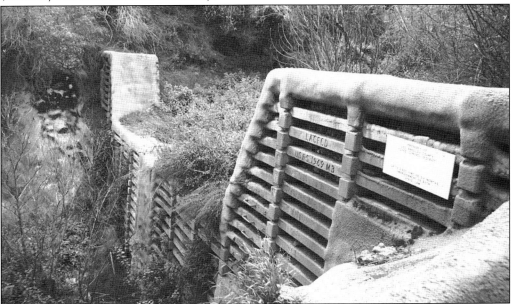

This debris dam was built in 1969, farther up the Arroyo Seco, by the Los Angeles County Flood Control District. Hundreds like it were placed in the canyons of the front range above Pasadena. The dams were intended to slow the flow of water and sediment, but over time, they became filled to the brim with gravels and plants, as this one has been, reducing their effectiveness. (Photograph by Gabi McLean.)

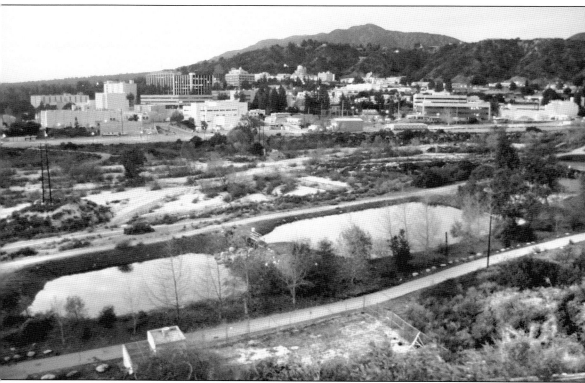

Gone are Judge Benjamin Eaton's pipelines from Devil's Gate to the colony below, but here is a modern method of harnessing the Arroyo Seco's waters for use by Pasadena. These are spreading basins near the large complex of the Jet Propulsion Laboratory (JPL), located just where the stream emerges from the mountains to the valley. Water retained here percolates into the porous gravels of the site and can be pumped out from the aquifer below the city when needed, via the city's wells. (Photograph by Gabi McLean.)

Six

THE PLANT KINGDOM

When Pasadena's original ranchers and colonists arrived in the 19th century, they found beside the Arroyo Seco a sloping plain of sparse grasses and shrubs. In the spring, there were abundant wildflowers, including the golden poppy fields in the uplands. Scattered oak trees made islands of shade. Some of the mature oaks were gentle giants, which had sheltered wildlife and provided acorn food to the native people for several centuries.

In the stream canyons, vegetation was more lush, with alder, sycamore, and cottonwood trees forming a canopy. Much of the Arroyo Seco had this luxuriant growth. The small streams flowing from Pasadena's southern edge held thickets of willow and wild grapevines. Some of the sycamores, along with the oaks, were true patriarchs, honored in many vintage photographs.

Agriculture steadily replaced the native growth, but oaks were often spared and left in the center of fields or even in the streets. By about 1915, these obstructing trees became centers of controversy, as "autoists" tended to collide with them at night. City officials finally voted in 1917 to remove "all traffic impediments of the treelike species," and many lamented their loss.

However, by that time, Pasadena had a municipal nursery and a program for tree-lined streets. An official tree was designated for each thoroughfare. Pepper, camphor, magnolia, acacia, and palms were among the exotic species popular for the streets. Pasadenans enjoyed bringing the flora of the world to their own corner of paradise. Huge climbing roses nearly hid some early cottages.

Today the native plant communities are once again admired where they exist at the urban edges. Riparian (streamside), coastal sage scrub, southern oak woodland, and chaparral are all thriving habitats, especially in Eaton Canyon and the foothills. There are many sources for knowledge and for the plants themselves, as this region awakens to the beauty and conservation value of its original flora. The city's Tree Preservation Ordinance gives special protection to Pasadena's native trees, and native landscaping is greening Pasadena in harmony with nature.

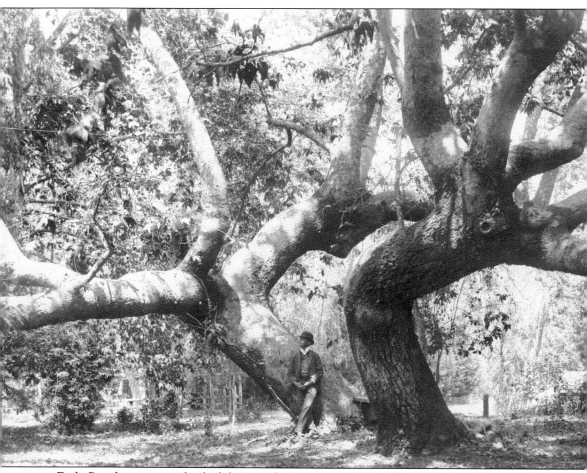

Early Pasadenans were fond of their prodigious trees, which offered islands of shade in the hot climate. They delighted in having their pictures taken with the grandest specimens, like this western sycamore. These trees can reach 90 feet in height, with large and crooked branches sweeping near the ground. The bark is characteristically patchy, and the five-fingered leaves are smooth, almost velvety. Some of the hummingbirds gather soft fuzz from the underside of the leaves to line their nests. Little balls of flower clusters hang from the tree branches. Leaves of this deciduous tree turn golden in autumn. Sycamores are water-loving trees, common along streamsides; a huge one can be found in Eaton Wash near the Nature Center. These trees lean too picturesquely to be good street trees, but some fine old examples line Arden Road in Pasadena. (Courtesy Pasadena Museum of History.)

Some of Pasadena's largest native trees, like this coast live oak in the center of Orange Grove Avenue, were spared within the colony's earliest roads. For 30 years, buggies could pass without incident. But with the advent of the automobile, they were declared a menace and removed, though prominent architect Elmer Grey lamented in 1917 that we are "striking down . . . so many fine old friends." (Courtesy Los Angeles Public Library.)

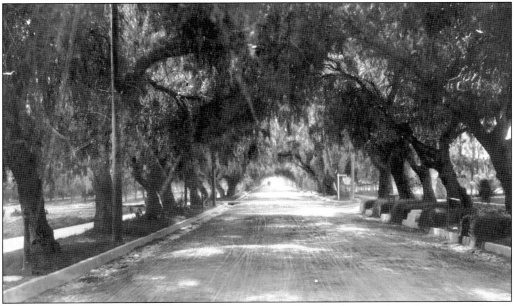

These rows of pepper trees made Marengo Avenue one of Pasadena's most admired streets. Although called the California pepper tree, these are actually native to Peru. Their gnarled trunks and gracefully drooping leaflets are a picturesque sight. Along a street, these trees can interfere with paving and sewers, but since earliest Pasadena had neither, they graced the roadways for a time. (Courtesy Pasadena Museum of History.)

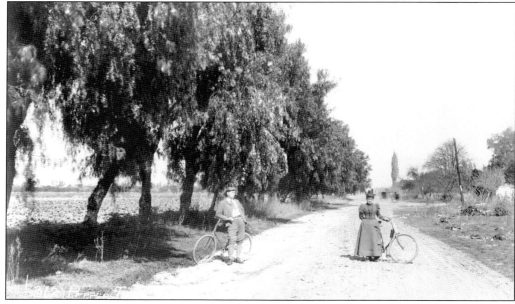

By 1915, Pasadena had an active street tree program, including the pepper-lined Marengo Avenue. The city reported that it had set out about 18,000 young trees and had an additional 30,000 trees growing in the municipal nursery. These are large numbers, but a San Francisco newspaper that year pronounced: "Pasadena looks like a forest city from the heights as you look over it." (Courtesy Pasadena Museum of History.)

Walking in the poppy fields was a favorite spring pastime. The blooms' fiery colors swept across the open land and around the homesteads and orchards, too. One booster wrote in the 1880s, "Almost every day can be spent out-of-doors, and this is the life to lead." (Courtesy The Huntington Library.)

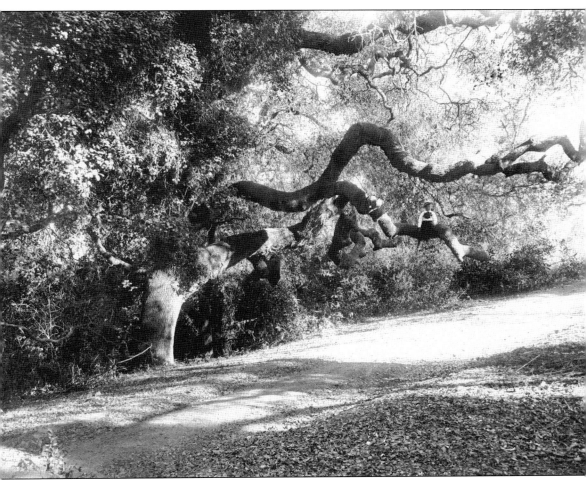

It was an idyllic childhood in early Pasadena with trees like this ancient coast live oak to climb. The oaks seemed to have a mystical beauty, which touched the settlers of any age. This species is relatively low and wide-spreading, evergreen, with a dense crown. Its crooked limbs may touch the ground, and some trees spread to 120 feet across. They commonly exceed 250 years of age. The acorns of the coast live oak have provided the staple diet for at least 12 major tribes of Native Americans in California. This species is the signature tree of California's coastal plains, foothills, and valleys, from the Mendocino coast to northern Baja. To appreciate the glorious architecture of an old one, stand close to its trunk and look up. Untold numbers have been lost to development, but fine ones can still be found in the canyons. As native trees, coast live oaks in city gardens must be fiercely defended against too much water, or they are lost. (Courtesy Pasadena Museum of History.)

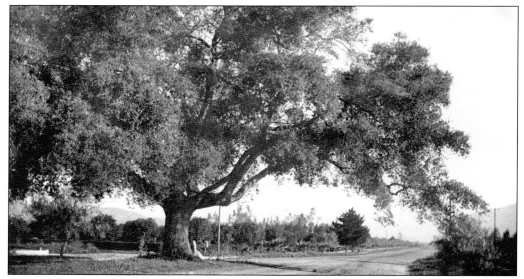

Pasadena's early architecture is framed here by the form of this coast live oak on Orange Grove Avenue. In the distant background is the tower of Prof. Thaddeus Lowe's residence, an imposing home but here just a glimpse. Lowe was the creator of the Mount Lowe Railway, which carried thousands of visitors into the nearby mountains between 1893 and 1937. (Courtesy Pasadena Museum of History.)

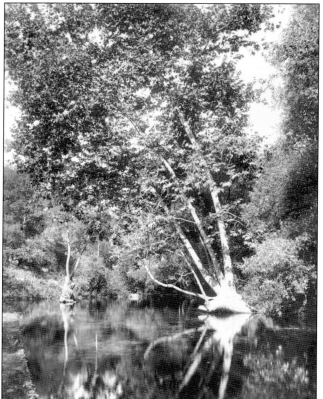

The white alder is a member of the birch family and may attain 100 feet in height. They appear to bear tiny cones, though these are actually the female flowers of the tree. Those who walk in Pasadena's canyons know them as water-loving trees whose reflections make little vistas where the streams are quiet. (Courtesy Pasadena Museum of History.)

The bouldery landscape interlaced with trees made many beautiful combinations along Pasadena's wild edges, as discovered by this group exploring an unidentified canyon in 1887. (Courtesy Pasadena Museum of History.)

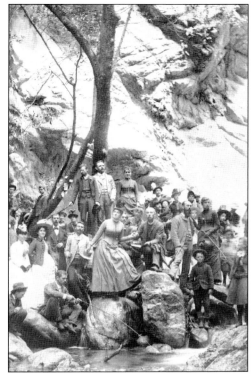

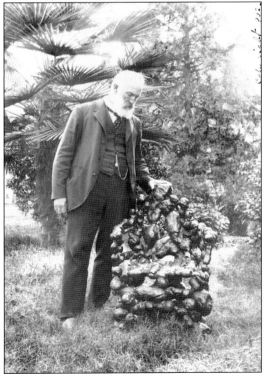

Theodore Parker Lukens (1848–1918), shown here with a curious chair made of roots, was a friend of John Muir and a father of Southern California forestry. He arrived in Pasadena in 1880 and became a *zanjero*, or tender of water ditches, for Benjamin D. Wilson's water company. Later he was a banker, city councilman, and mayor of the town, but his passion was trees. In the mid-1890s, he began the first reforestation experiments in California, at Henninger Flats (still a county tree nursery) along the Mount Wilson Toll Road. Eventually he sent thousands of seedlings to the new Griffith Park and other sites. The *Los Angeles Times* compared him to Johnny Appleseed. He believed that planting trees would change the Southern California climate to include greater rainfall. His conservation ideals brought him a warm friendship with Muir, and their correspondence about trees is held in The Huntington Library. Mount Lukens in the San Gabriel Mountains is named for this Pasadena pioneer. (Courtesy Pasadena Museum of History.)

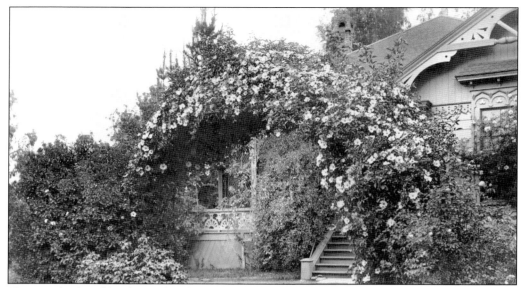

Huge rosebushes, like these Cherokee roses covering a cottage, dazzled Eastern visitors. Pasadena photograph archives hold many pictures like this. One wonders where the big climbing roses have gone from Pasadena today. Perhaps there is no longer water to spare for them in the gardens, or they have just gone out of fashion. (Courtesy Pasadena Museum of History.)

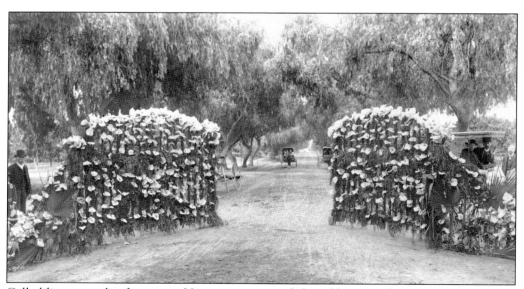

Calla lilies were a big favorite in Victorian times, and these lily-covered gates were showing off Pasadena's pride as a little Eden. "Every hour here seems an hour borrowed from some paradise," declared a 19th-century pamphlet. (Courtesy Pasadena Museum of History.)

In 1880, Ezra and Jeanne Carr, friends of John Muir, stood beside this rustic cabin on their property called Carmelita. They owned 42 acres along the north side of Colorado Boulevard from Orange Grove to Fair Oaks Avenue (site of the Norton Simon Museum today). The Carrs planted over 90 species of unusual trees and a Cherokee rose border all along Colorado. Once a scrubby sheep pasture, Carmelita became a garden sanctuary. (Courtesy Pasadena Museum of History.)

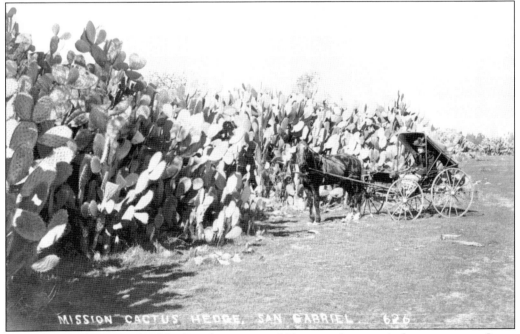

The vigorous plant growth of the Pasadena area could be turned to practical purposes, too. Some properties were bordered with formidable hedges of mission cactus, which separated livestock from fields, a method used on San Gabriel Mission lands. (Courtesy Pasadena Museum of History.)

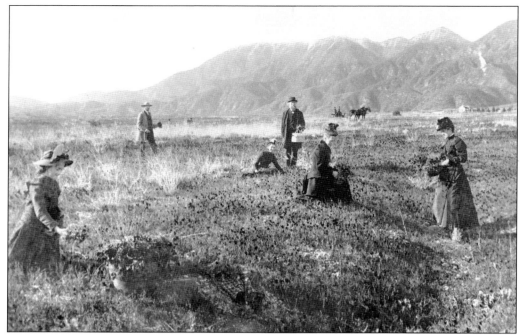

The California poppy was once common across the grassy slopes above Pasadena, as witnessed today by the name of Poppy fields Street in Altadena. The Spanish Californians called this plant *Dormidera*, the drowsy one, because its petals fold at dusk. These early Californians, according to native plant authorities, made a hair dressing by frying the petals in olive oil to impart a glossy shine to their hair. Today the bright spread of bloom now gone from the Pasadena colony can be seen, in good years, in the desert or the Antelope Valley preserves. (Above courtesy Pasadena Museum of History; below photograph by Gabi McLean.)

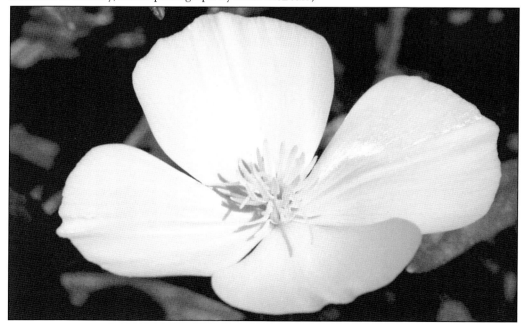

Native plant communities near Pasadena appear here in layers, viewed from Eaton Canyon. Lowest is the rocky wash, then alluvial scrub, such as this mulefat, adapted to frequent drought. Next is the dark band of southern oak woodland, marked by coast live oak and an understory of golden currant and poison oak. Above on the dry slopes is the chaparral, with laurel sumac, the sages, and buckwheats. (Photograph by Gabi McLean.)

A year-round water source may be bordered by riparian woodland, with more lush vegetation such as these white alders in the Upper Arroyo Seco. Mature alders develop the distinctive "triangle" markings on their trunks. Western sycamores, cottonwoods, and willows might also be found in this plant community. (Photograph by Gabi McLean.)

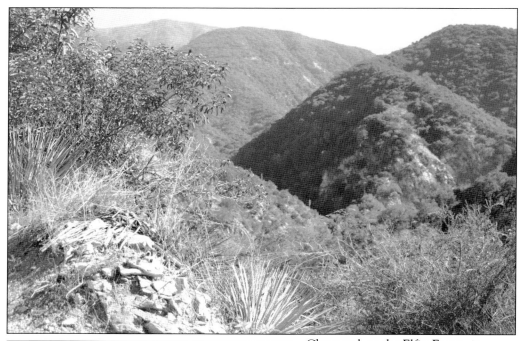

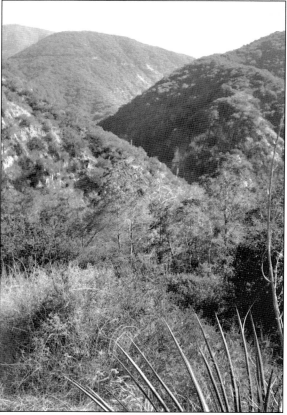

Chaparral, or the Elfin Forest, is dominated by large evergreen shrubs, dense, brushy, and richly aromatic in the sunlight. These closer views show the rocky/gravelly terrain, a spiny yucca and laurel sumac in the foreground. Beyond are rounded ridges, with shaded north-facing slopes and exposed sunny sides. Chaparral is shaped by the Mediterranean climate of mild wet winters and hot dry summers. It forms a dense gray-green cloak on mountainsides, often impenetrable to humans and large animals. Other common chaparral plants are ceanothus, chamise, manzanita, toyon, and hollyleaf cherry. Rocky outcrops provide vantage points across the landscape. (Photographs by Gabi McLean.)

The Southern California black walnut, a native walnut, is uncommon but is a handsome small tree with this distinctive foliage of parallel leaflets. It may be found in groves in moist areas or on north-facing slopes. (Photograph by Gabi McLean.)

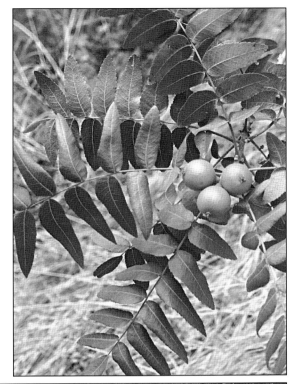

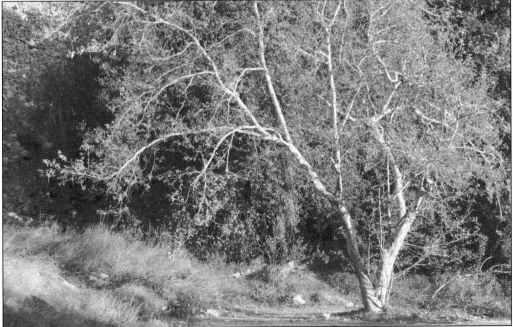

This western sycamore shows an elegant form, having not yet reached the status of well-aged patriarch. It is growing in San Gabriel Canyon, the major watershed of the San Gabriel Mountains, to the east of Pasadena. (Photograph by Gabi McLean.)

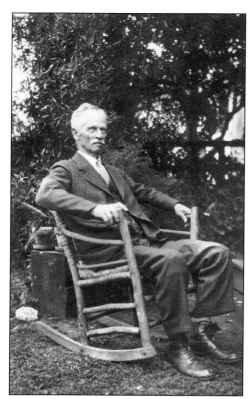

Charles Francis Saunders (1859–1941) was a famed naturalist and author, a Philadelphia Quaker who came to Pasadena in 1906. He was also a skilled photographer and an advocate of Native American rights. His numerous books on wildflowers and the Southern California mountains still delight nature lovers today. His collection of Native American artifacts is in the Southwest Museum, and his Pasadena bungalow has been named a city landmark. (Courtesy The Huntington Library.)

The pale gray leaves of the white sage appear almost white, and its lavender flowers are attractive to bees, yielding a clear, fine honey. This member of the mint family is common in chaparral and oak woodland settings. The Native Americans made tea from its leaves and burned bundles of the leaves as aromatic smudges for ceremonies. (Photograph by Gabi McLean.)

In these two views, the canyon live-forever shows its distinctive form: a silvery rosette of plump leaves. It sends up short flowering stems, and its heart may be threaded with fine spiderwebs. The plants are neat and ornamental and often picturesque in the rocky cliffs and clefts, part of nature's rock garden. These are familiar in the canyons around Pasadena. (Photographs by Gabi McLean.)

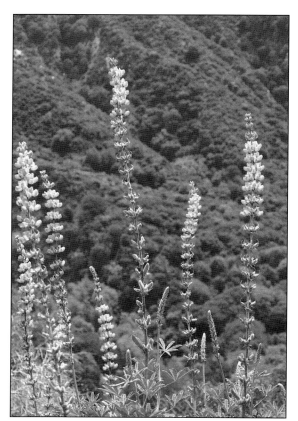

This bush lupine is one of many native lupines of California, found in chaparral and coastal sage communities of Pasadena's nearby mountains. It is a stout shrub that may reach 5 feet in height; the bluish flowers have the typical pea-shape, a welcome wild bloom from April through June. (Photograph by Gabi McLean.)

The chaparral community depends on wildfire for its continuing life. Chaparral shrubs are very flammable because of their resinous foliage and dry leaf litter. Some are adapted to survive a fire by crown sprouting (shown in this photograph). Fire also clears open spaces where annuals can take hold. Some seeds germinate only after fire; these so-called "fire followers" may reappear after having not been seen for decades. (Photograph by Gabi McLean.)

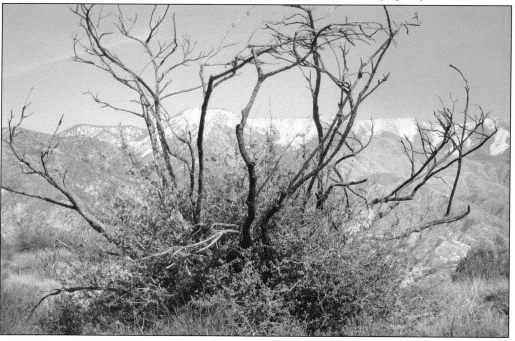

Seven

THE ANIMAL KINGDOM

Pasadena's first settlers shared their lands with their own Eden of animals and birds. Dr. Hiram Reid, the town's witty and thorough historian, gave an overview of the native mammals, reptiles, and insects common in 1895. These creatures were part of daily rural life.

Abundant were the jackrabbit, kangaroo rat, and gopher ("few . . . have not watched with amazement gallons of valuable water disappear in the holes of these tyrants of the garden"). Reid marveled at the tree rat, with twig nests 3 feet high composed of rooms and passageways. Raccoons and skunks amused him, and badgers were common. Mule deer, he says, rarely ventured into the lowlands. A bat species with a wingspan of 18 inches was noted, and he once saw a red racer snake attempting to strangle a weasel—but the weasel was the victor.

Magnificent but more troublesome were the mountain lions, coyotes, and bears. There were many anecdotes about these creatures in the first 20 years of the colony. A lion killed one of Benjamin Eaton's gentle driving horses near Eaton Canyon. Although usually confined to the mountains, lions were sometimes met on the trails or ventured down toward the sheep corrals.

Bears were frequent visitors to the homesteads, raiding beehives or carrying off a calf into the canyons. The coyotes, those wily predators, would trot at night down Orange Grove or Marengo Avenue, in the heart of town, their "demoniac laughing-bark" setting the dogs wild.

Young Joseph Grinnell, who later became a renowned naturalist, provided Reid's account of native Pasadena birds in 1895. He lists 168 species within an 8-mile radius of the village center! This does not include water birds, estimated by Reid at 20 to 30 species. Called "very common here" was the roadrunner, once observed zipping up unpaved North Lake Avenue into an apricot orchard with a long gopher snake in its bill.

The quail (in immense coveys), hawks, owls, woodpeckers, and songbirds were familiar companions to early Pasadenans. Today urban wildlife can still be found to delight those who patiently observe.

In 1899, John Muir advised several young friends to "pursue some branch of natural history at least far enough to see Nature's harmony." That harmony is evoked in this elegant drawing by Pat Brame for the Eaton Canyon Nature Center. Deer, raptor, coyote, and raccoon join the natural setting of stream, mountain, and cloud under a branching sycamore. The modern study of ecology explores the physical environment (soil, air, water, and sunlight) and the living organisms it contains. Complex interrelationships make the ecosystem a vibrant whole. Whether in a Pasadena backyard or an ancient watershed like Eaton Canyon, the creatures depend on each other in many ways. Every living thing has its niche, and Pasadena's wildlife has evolved over time as the city grew. Today a coyote may capture a cat or a raccoon visit a dog food bowl. But in the mountains and canyons, they can pursue their wild ways undisturbed. (Courtesy Eaton Canyon Nature Center.)

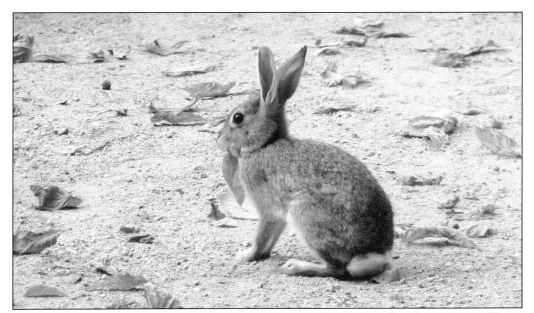

Audubon's cottontail is a fairly large, long-legged cottontail with short fur. Shown here in Eaton Canyon, it makes a familiar stir along brushy trails and also may live in deserts and orchards. One authority on mammals reports it has been known to climb into small trees, evidently to drink dew from the leaves. (Photograph by Chuck Haznadl.)

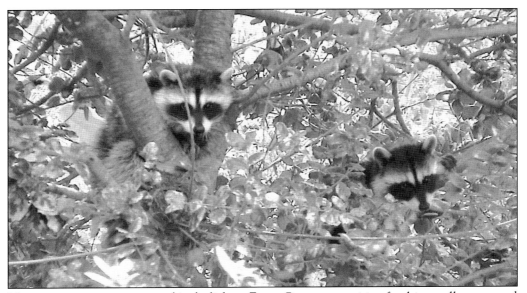

These young raccoons appeared in daylight at Eaton Canyon, surprising for this usually nocturnal species. Raccoons are very curious and like to handle everything with their small hands. Most of their life is spent near water, and they often wash their food. Sociable and adaptable creatures, they are common in woodlands and also urban areas. In the city, they may live in storm drains or culverts. (Photograph by Chuck Haznadl.)

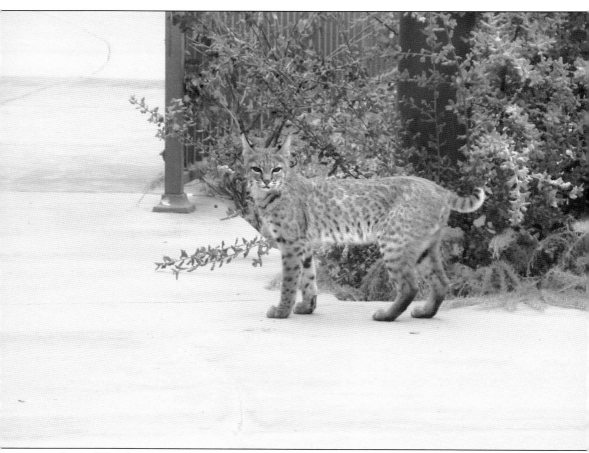

One of Pasadena's most beautiful mammals is the bobcat, a creature of the canyons and urban edges. This one was just a few feet from the doorway of the Eaton Canyon Nature Center. Much smaller than the mountain lion, which usually keeps to the higher reaches of the mountains, this cat has been seen in the gardens and wild edges of Linda Vista, Annandale, and Altadena. Its short, white-tipped tail, tufted ears, and broad whiskers are distinctive. Bobcats may be quite bold and look right back at a human observer. They are opportunists in their diet, which includes rabbits, squirrels, mice, gophers, reptiles, and birds. They have even been observed catching bats that are approaching water to drink. (Photograph by Chuck Haznadl.)

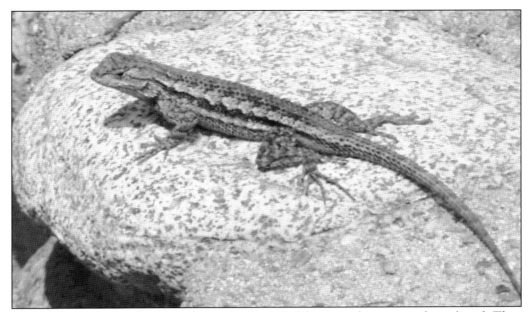

One of the most abundant reptiles in Southern California is the western fence lizard. They like canyons and a rocky habitat, which offers sheltered niches and spaces for sunning. They are excellent climbers, zipping across vertical or even overhanging rock faces. In coloring, they resemble the rocks themselves. These lizards reappear quickly in fireswept areas. (Photograph by Chuck Haznadl.)

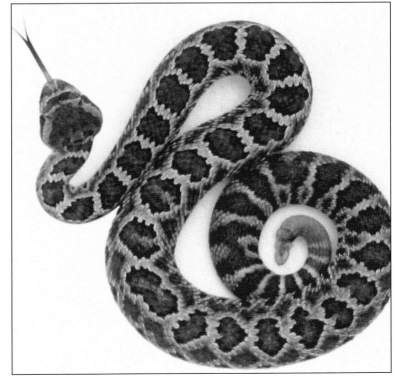

This Southern Pacific rattlesnake, captured here in a bucket, shows off its sinuous form. Rattlesnakes like to haunt rocky outcrops and hillsides, stream courses, and areas with downed logs. They are common in the wild places around Pasadena, but they avoid human contact. Mostly active from April through September, they provoke respect and require a healthy distance. (Photograph by Chuck Haznadl.)

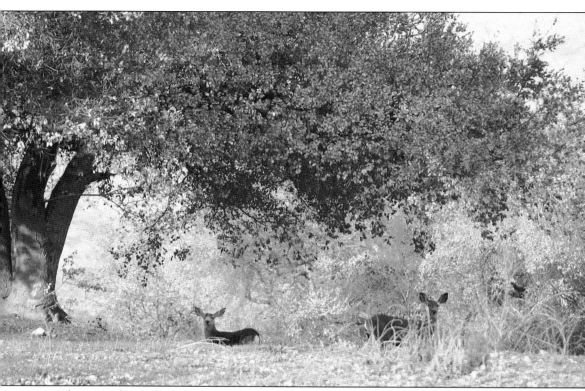

This coast live oak shelters several mule deer in a foothill niche near Pasadena. A mature oak forms a little ecosystem in itself: naturalists estimate that over 330 species of mammals, birds, reptiles, and amphibians depend on oak woodlands—as do hundreds, perhaps thousands, of insect species. The oaks provide shelter, food, nesting sites and nest materials, and creatures who come to feed on other creatures. Even the native people before the Pasadena colony, the Tongva, depended on acorns as their staple food. Oak woodland occupies the gentle slopes and valley land where rich soil has accumulated. These deer, a familiar sight to hikers, enjoy the midday shade. Farming, grazing, and land development have cost the lives of many Southern California oaks. Preservation efforts are underway for all of California's 18 species of oaks, which range from majestic trees to canyon shrubs. In Pasadena, the coast live oak, valley oak, canyon live oak, scrub oak, and Engelmann oak all have special protection under the city's Tree Protection Ordinance. (Photograph by Gabi McLean.)

Resting on a chaparral currant is the western tiger swallowtail, a bright-yellow creature with much black over its wings and yellow markings around the margins. These are migrant butterflies and a familiar sight in woodlands, streamsides, and the wild places as well as in urban parks, roadsides, and city yards. (Photograph by Gabi McLean.)

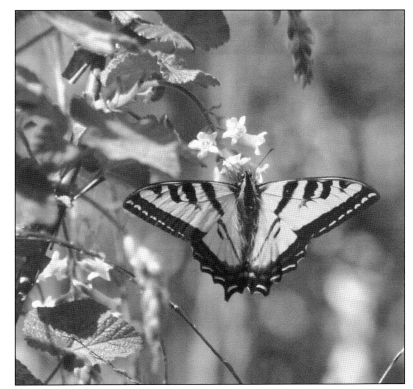

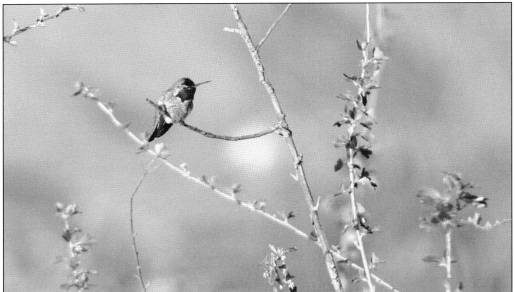

Anna's hummingbird is Pasadena's most familiar little hummer. Joseph Grinnell, writing for Hiram Reid's history of 1895, called them the only resident hummingbird then, common all the year. This is still true 100 years later. Grinnell reports that one nested in Pasadena as early as January 22. Today the Anna's is found in chaparral and open woodlands, as well as flower gardens. (Photograph by Gabi McLean.)

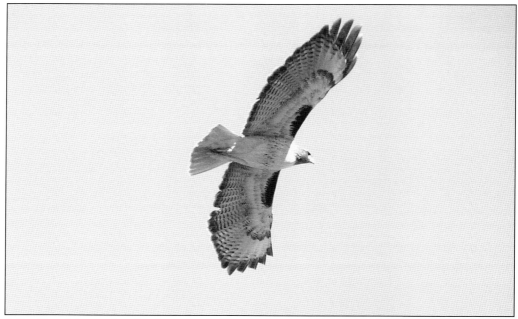

A familiar sight overhead is the red-tailed hawk, chunky and broad, with a short tail distinctively red in the adults. Its whistled scream is unforgettable, and it is often a sentinel on treetops or poles. The early settlers referred to them as "chicken hawks" because they were enemies of the poultry yards, but they were also much valued for destroying mice and squirrels. (Photograph by Ron Cyger.)

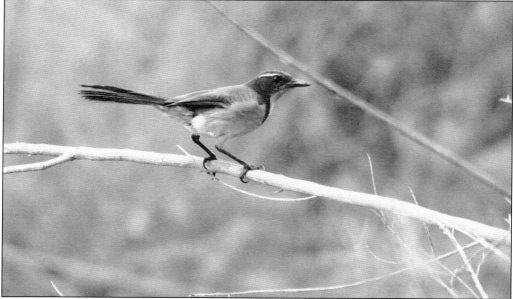

The western scrub jay is a common and noisy resident of the chaparral and oak woodlands. A blue-and-gray member of the crow family, it can be bold and aggressive, sometimes devouring the eggs of smaller birds. Around picnic areas, these jays approach busily and may even take food from the hand. (Photograph by Gabi McLean.)

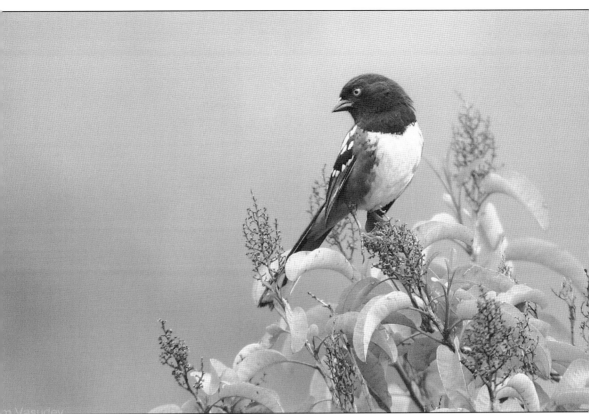

The spotted towhee, shown here on a laurel sumac shrub, is common in Pasadena's wild edges: Eaton Canyon and the Arroyo Seco brushlands and sunny clearings. The male's russet flanks and black-and-white tail are easily recognized. In 2006, this bird was named an "indicator species" in a study of Arroyo Seco watershed health, prepared by the conservation groups North East Trees and the Arroyo Seco Foundation. They chose four birds whose prosperity would show the success of four habitat types: the spotted towhee for scrub (coastal sage scrub and chaparral); the oak titmouse for oak and walnut woodlands; the yellow warbler for riparian (streamside) habitats; and the California quail for connectivity of habitats. The towhee lives by foraging on the ground for seeds and insects. In the Arroyo Seco, much of its wild habitat has been lost to development and flood control measures, so its fate is being watched. (Photograph by Ram Vasudev.)

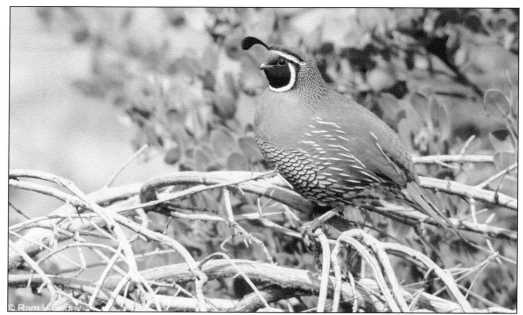

The California quail, the state bird, is another species being studied in the Arroyo Seco to see whether its habitat is thriving. Pasadena's early settlers reported "immense coveys" of these sociable birds. Their nests, hidden in vegetation on the ground, contain as many as 12 eggs but are vulnerable to predators. Their familiar call—"chi-CA-go"—is a reassuring presence in Pasadena's wild edges. (Photograph by Ram Vasudev.)

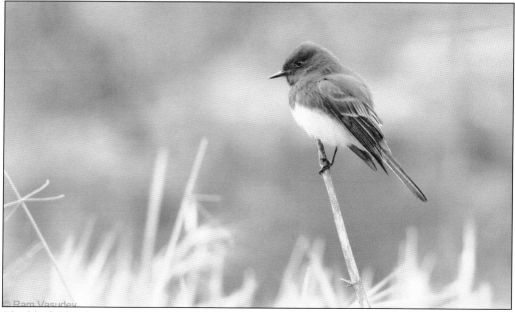

The black phoebe, called the pewee by the early colonists, was common then and now. It would perch on a hitching post, then make quick sallies into the air to snap up an insect, returning to its perch. The aerial maneuvers of this little black-and-gray flycatcher can be quite a delight. Its presence often indicates water is nearby. (Photograph by Ram Vasudev.)

The raucous laughing call of the acorn woodpecker makes it conspicuous in oak woodlands or anywhere near oaks. Its clownish black-and-white face is topped with a red crown. These woodpeckers, who flock in noisy colonies, store hundreds of acorns in trees or wooden utility poles to eat later. Look for them in Eaton Canyon or a nearby telephone pole. (Photograph by Ram Vasudev.)

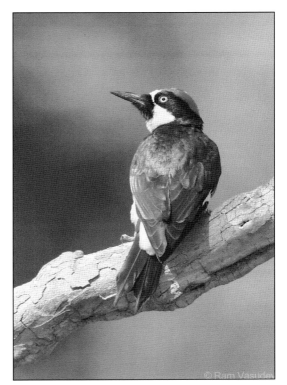

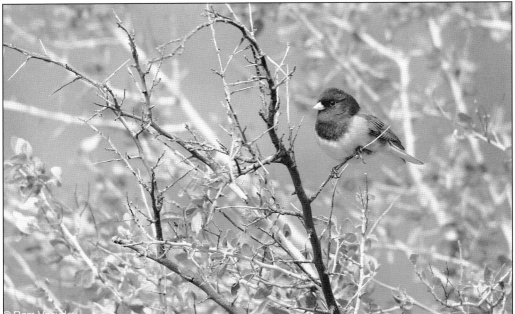

A sooty or blackish hood marks the dark-eyed junco, a member of the sparrow family. This is another ground feeder, foraging in open brushy areas, sometimes in small flocks. They are summer residents of the mountain forests, moving to the more open lowlands after nesting. (Photograph by Ram Vasudev.)

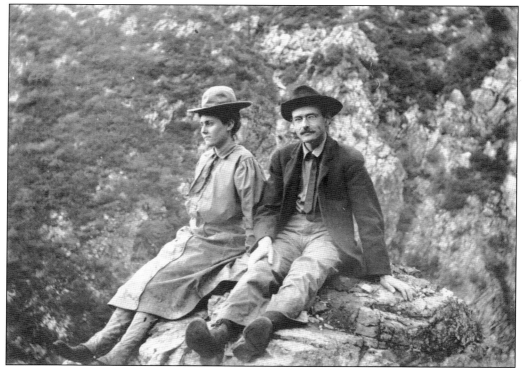

Joseph Grinnell (1877–1939), shown here in 1906 with his wife-to-be, Hilda Wood, in Eaton Canyon, became the premiere ornithologist of California. A keen field observer, he was also a professor at Throop Polytechnic Institute (now Caltech). He was a well-loved teacher; his theory of "ecological niches" is still a basic principle of nature study. His wife became an important zoologist herself. (Courtesy Bancroft Library.)

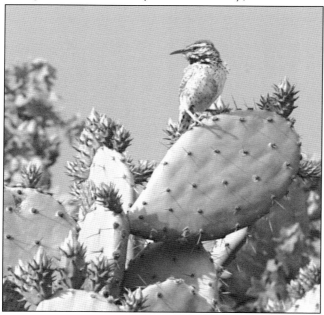

This cactus wren, here on a prickly pear cactus, is found in sagebrush scrub and builds its nest of sticks in the fork of cactus. It is a bit larger than its relatives, the house wren and Bewick's wren, common in Eaton Canyon. Wrens are small brown birds, active and often hidden. Joseph Grinnell mentioned the cactus wren in his 1895 report on Pasadena birds. (Photograph by Gabi McLean.)

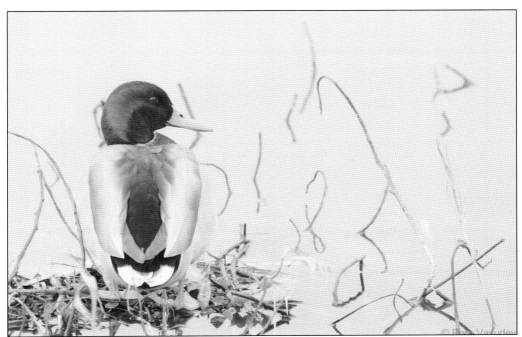

Although it is so familiar, the mallard deserves a second look for its distinctive plumage: the male with its emerald green head and pale body, the female a mottled brown. Many domesticated varieties now also inhabit local waterways, and they are widespread from wild areas to city parks. Mallards nest in the unchanneled stretches of the Arroyo Seco, on the ground near stream edges, bursting out with their ducklings as a student clean-up crew pulls out a bit of urban trash nearby. Mallards are the most common of Pasadena ducks and are found worldwide in temperate regions. (Photographs by Ram Vasudev.)

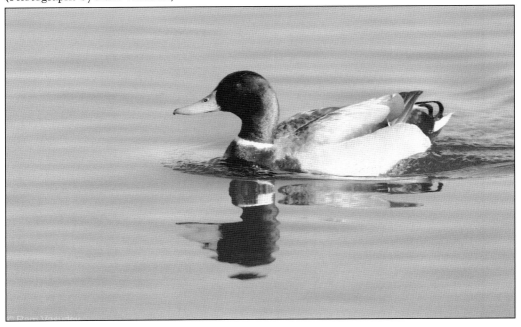

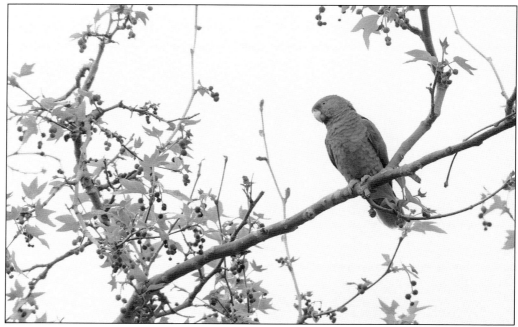

No native parrots are left in North America, but exotic species, like this bright green lilac-crowned parrot, thrive in Southern California in noisy flocks. They may have originated as escaped pets or smuggled contraband. A flock near Temple City's Live Oak Park has numbered over 1,100; these scatter out at dawn with wild cries, to forage in fruit trees around the Pasadena area. (Photograph by Ram Vasudev.)

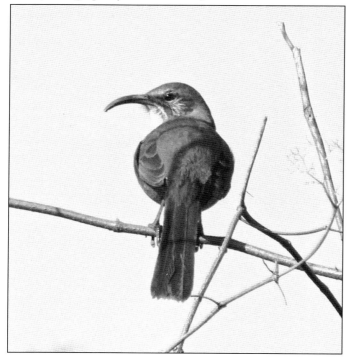

This handsome profile belongs to the California thrasher, a common but often secretive bird of the chaparral. Thrashers belong to the bird group called mimids, which also includes mockingbirds. The mimids sing in distinct phrases that are often repeated. This thrasher is usually seen foraging in leaf litter on the ground, using its distinctive curving bill. (Photograph by Ron Cyger.)

Eight

RESTORING AND PRESERVING PASADENA'S NATURE

Pasadena is now a thriving urban center with a population of 146,000, many generations beyond its origins in the 1860s and 1870s. Much of the natural habitat once around the town is gone, no longer within living memory.

Visitors to stylish Old Pasadena today may be amazed that, before 1895, a winter pond at the northwest corner of Colorado Boulevard and DeLacy Street was filled with frogs, their melodious song heard throughout the town at night. Residents of Pasadena's uplands may not know that the glowing poppy fields there (it is said) could once be seen by ships at sea.

Change happened rapidly after the land boom of the 1880s. William Hamlin Hall, the state engineer surveying Southern California's irrigation, wrote in 1888: "The 'boom' has swept over this fair colony. . . . The city of Pasadena is claiming some of the best orange lands to pave under with rock or build over with brick. Residences are multiplying, orchards and vineyards are giving place to ornamental gardens and lawns."

Pasadenans began early to protect their natural resources, even as the city grew. In 1902, the first city parkland, for Central and Memorial Parks, was acquired. The city took charge of street tree planting in 1905. Between 1911 and 1927, the city bought the lands of the Central and Lower Arroyos for parks. Eaton Canyon, now a Los Angeles County natural area, was planned in 1932 to be open space from the mouth of the canyon to the southern city limit.

Citizen groups have long been involved also. The Pasadena Audubon Society, founded in 1904, has been conserving and studying Pasadena's nature for more than 100 years. The Sierra Club, the California Native Plant Society, and other organizations are raising awareness, too.

Today Pasadena has over 1,000 acres of designated parkland. The urban forest is mature and varied. City agencies are working with new opportunities to preserve open space. Pasadena is striving to live in harmony with nature, and there is a role for everyone to help realize this ideal.

Eaton Canyon Nature Center is the hub of nature study in Pasadena and the surrounding area. The building shown here was dedicated in 1998, five years after a wildfire swept down the canyon and destroyed the previous center. Around the Craftsman-style building is a 190-acre natural area, with abundant trails, nooks, and crannies of the main canyon and its tributaries. There are many programs for all ages: student naturalist activities, bird and plant walks, explorations to the waterfall, moonlight walks, and more. Volunteer programs have opportunities for everyone. Young visitors share in the spirit of "no child left indoors!" (Photograph by the author.)

Several environmental groups hold regular meetings at the Nature Center: their newsletters, shown here, include *Paw Prints* (Eaton Canyon), *The Wrentit* (Pasadena Audubon), *The Paintbrush* (California Native Plant Society), *Arroyo View* (Sierra Club), and *Southwestern Herpetologists Society Newsletter*. All these groups welcome new participants. (Photograph by Chuck Haznadl.)

A family walks along the Eaton Canyon wash in the 1980s. The stream flow varies greatly with winter rain conditions, and sometimes it is necessary to boulder hop or cross on a convenient plank in order to continue the ramble upstream. Much of the time, the wash is dry near the Nature Center and can be explored for rocks and lizards. (Courtesy Los Angeles Public Library.)

In 1998, a water company attempting to repair its pipelines in Rubio Canyon caused a huge rockfall, which covered the once-beautiful waterfalls admired in Prof. Thaddeus Lowe's day (see page 45). How to remove the massive rocks and restore the falls was debated for several years. Nature intervened with an intensely rainy year in 2004–2005, and much of the debris was swept naturally down the canyon. Final steps to break up some of the largest boulders may restore Rubio Canyon to a new version of its historic beauty. (Photograph by Paul Ayers.)

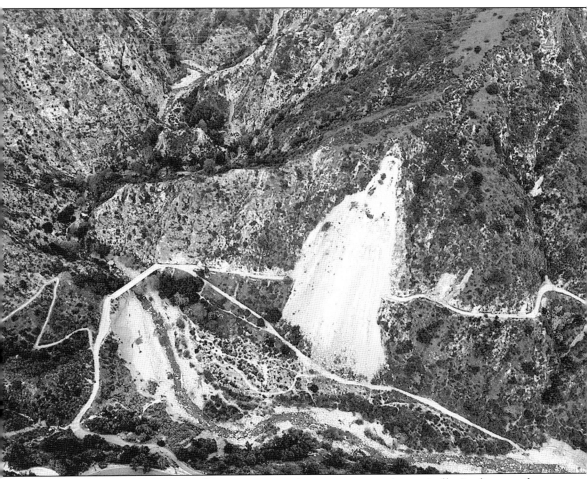

The San Gabriel Mountains are always moving and sometimes very dramatically. In the record-testing rains of 2005, the mountain slope rearranged itself and obliterated a long stretch of the Mount Wilson Toll Road, as seen in this aerial photograph. For an idea of scale, the white line across the center of the picture is a two-lane dirt road. Note the bridge at the center left, crossing the dry Eaton Canyon wash. The area of the slide is steep and loose, not promising for cutting a restored roadway across its face. The Mount Wilson Toll Road, although it retains that name, is no longer a public road for vehicles, but hikers and mountain bicyclists have enjoyed it for years. The road, which leads to Henninger Flats and on to Mount Wilson, has been dedicated to county fire access. (Photograph by Renee Strouse, Aerial Art Photography.)

An important figure for restoring and preserving Southern California nature was Theodore Payne (1872–1963). He was an Englishman who came to California in 1893 and became an ardent advocate for native plants. Seeing that the state's rich native flora was quickly disappearing, he grew demonstration gardens and carried on a thriving nursery to promote gardening in harmony with the natural climate. (Courtesy Theodore Payne Foundation.)

A successful project of Theodore Payne was the native plant garden at Descanso Gardens, a Los Angeles County park west of Pasadena. Payne developed this native plant area in 1958, then lived and worked into his 90s. The Theodore Payne Foundation and Nursery in Sun Valley, California, carries on his mission and grows hundreds of species of plants and seeds. (Courtesy Pasadena Museum of History.)

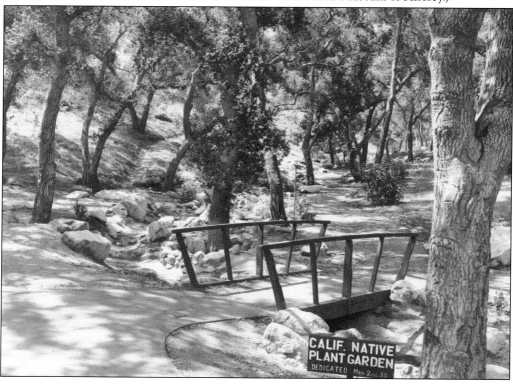

CALIF. NATIVE PLANT GARDEN
DEDICATED May 2nd.59

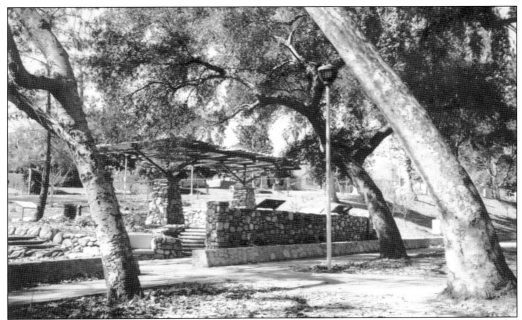

Washington Park in Pasadena was designed in 1922 by Theodore Payne and the noted landscape designer Ralph Cornell. The site was a natural stream basin, one of many that used to flow downslope through Pasadena (at least seasonally). Such natural watercourses have almost all been graded away now and their flows submerged in underground culverts. But the interesting topography remains at Washington Park, complete with multiple levels, river rock walls, and an old stone bridge. Recently a major restoration effort brought back the neglected park, blending the mature trees with a new shade ramada and interpretive signs to highlight the native plants of the park. An active citizens group values the special history of this park and has organized the neighborhood to support its continuing life. (Photographs by the author.)

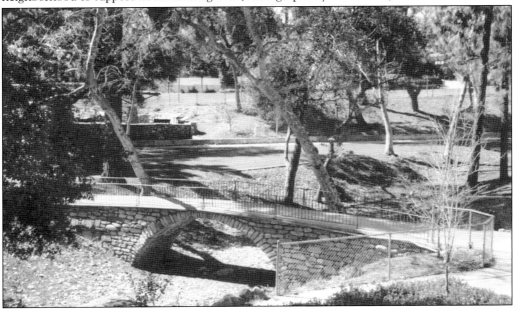

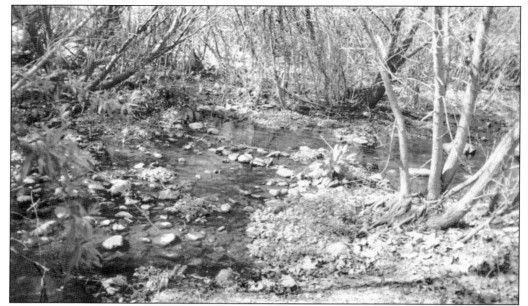

Many Pasadenans want the Arroyo Seco to regain its once-natural character. The concrete flood control channels remain, but the stream restoration shown here was done in the 1990s in the Lower Arroyo. This is actually an artificial diversion stream, which flows parallels to the concrete channel for a while, then rejoins the main channel downstream. Newly planted willows and alders have taken hold, forming riparian thickets. (Photograph by the author.)

Here students at an Arroyo Clean-up Day pull urban litter from the stream near the Colorado Street Bridge. These events are held several times a year and afford a chance to get wet feet as Pasadena's early children might have done when the waters flowed freely all along the arroyo. (Photograph by the author.)

Pasadena has had an official street tree program for 100 years. This Mexican fan palm corridor is along Del Mar Avenue east of Orange Grove Boulevard. The City of Los Angeles recently lamented the loss of many of its great palm corridors, which were planted as a local icon for the 1932 Olympics. Pasadena's corridors may date from that same time. (Photograph by the author.)

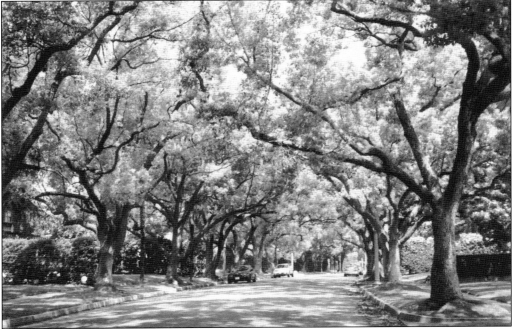

These camphor trees along Prospect Boulevard are characteristic and beautiful Pasadena trees. Their billowy crowns are light green and their trunks almost black in the rain. They form a little world of their own under their canopy. (Photograph by the author.)

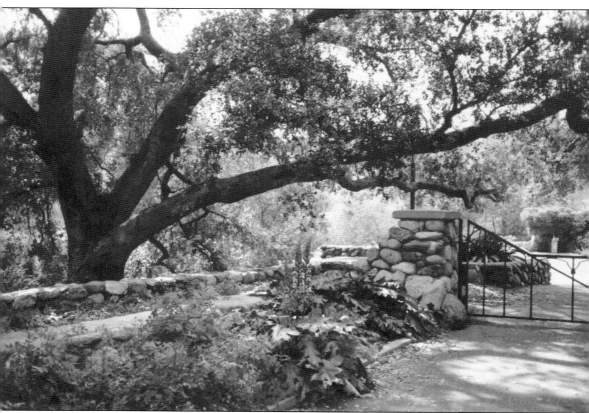

A familiar combination in Pasadena, almost a trademark now, is the beautiful stonework along the arroyo with the mature native oaks. Recently volunteers have cleared growth and revealed some of the stone walls and steps that once threaded along the arroyo slopes. Use of the natural river stone was characteristic of Pasadena architecture from the earliest days through the 1920s. There are still craftsman who can repair a vintage wall or rebuild an old stone chimney toppled in an earthquake. (Photograph by the author.)

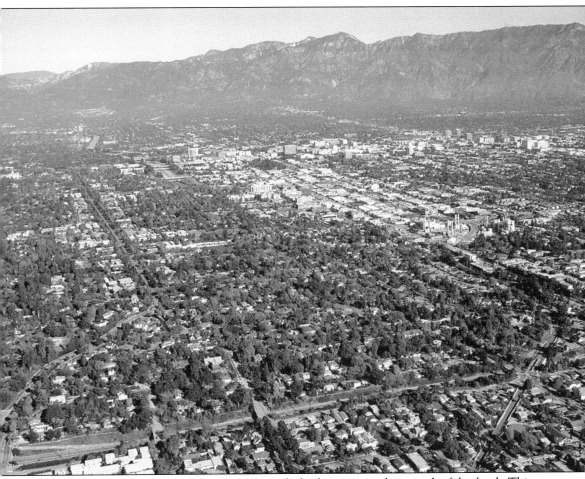

Compare this aerial photograph, taken in 2005, with the frontispiece photograph of this book. This modern view looks north and slightly east across the southwest corner of the city. The mountains look unchanged in the two views, with the familiar ridgeline. Pasadena has become fully developed, but its urban forest is an asset to the city dwellers who enjoy its canopy and the energy-conserving properties of its shade. (Photograph by Renee Strouse, Aerial Art Photography.)

DISCOVER THOUSANDS OF LOCAL HISTORY BOOKS FEATURING MILLIONS OF VINTAGE IMAGES

Arcadia Publishing, the leading local history publisher in the United States, is committed to making history accessible and meaningful through publishing books that celebrate and preserve the heritage of America's people and places.

Find more books like this at
www.arcadiapublishing.com

Search for your hometown history, your old stomping grounds, and even your favorite sports team.